IMAGES
of America

GRIFFITH PARK

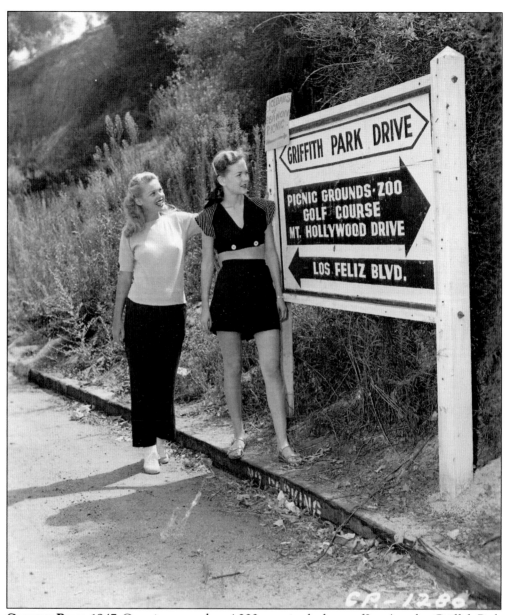

GRIFFITH PARK, 1947. Covering more than 4,000 acres in the heart of Los Angeles, Griffith Park is one of America's great urban oases. Donated by controversial philanthropist Colonel Griffith J. Griffith in 1896, the land has served as a public playground for 115 years. Lying adjacent to Hollywood, it has been a frequent filming and photo-op site for studio starlets like Sandra Spence (left) and Nanette Parks, pictured in 1947. (Courtesy Bison Archives.)

ON THE COVER: Griffith Observatory is pictured in 1941. For generations, the Griffith Observatory has been a favorite spot for Angelenos wishing to learn more about the stars above and to gaze over the city of Los Angeles below. The observatory was completed in 1935, nearly four decades after Colonel Griffith donated the huge parcel of land to the city to create the park that now bears his name. (Courtesy Bison Archives.)

IMAGES
of America

GRIFFITH PARK

E.J. Stephens and Marc Wanamaker

ARCADIA
PUBLISHING

Published by Arcadia Publishing
Charleston, South Carolina

Printed in the United States of America

Library of Congress Control Number: 2011928031

For all general information, please contact Arcadia Publishing:
Telephone 843-853-2070
Fax 843-853-0044
E-mail sales@arcadiapublishing.com
For customer service and orders:
Toll-Free 1-888-313-2665

Visit us on the Internet at www.arcadiapublishing.com

*This book is dedicated to the generations of hardworking
Griffith Park employees and volunteers who have preserved
and enhanced Colonel Griffith's grand gift.*

CONTENTS

ACKNOWLEDGMENTS

The authors would like to thank editors Jerry Roberts, Debbie Seracini, and all the great folks back at the Arcadia Publishing offices in South Carolina. Thank you to Los Angeles District 4 Councilmember Tom LaBonge, who was the catalyst for the creation of this book and has been a lifelong Griffith Park supporter and promoter. Thanks to Christina Rice of the Los Angeles Public Library Photo Collection, to Hollywood Heritage, and to the Autry National Center's Yadhira De Leon, Senior Manager, Public Relations. Thanks also to Donovan, Claire, Tony, and Alex, who run the first—and still the greatest—video store in the world, Eddie Brandt's Saturday Matinee in North Hollywood. The authors would especially like to thank dedicated, longtime Griffith Park Ranger Pat Aceves, who spent the better part of two weekends guiding E.J. through nearly every acre of the park.

When it comes to information on the history of Griffith Park, researchers are blessed that Mike Ebert already did most of the heavy lifting in *Griffith Park: A Centennial History*. Nearly 15 years after it was first published, this masterful publication is still the best source of information about the park. All images are courtesy of Bison Archives unless otherwise noted.

E.J. would like to thank his beautiful wife, soulmate, and editor, Kimi, for always being there, for continually waking with a smile, and for pinch-hitting on the blog during this book's final hours. He would also like to thank Pherbia Stephens, his wonderful mother, for her love and support over the years, and his wonderful stepkids, Mariah and Dylan, for helping make this time in his life the best yet.

Marc would like to thank his father, Dr. William Wanamaker, for being a Griffith Park enthusiast and for bringing him to all the wonderful Griffith Park attractions as a child.

INTRODUCTION

Here are some items that belong at the top of everyone's Los Angeles "bucket list":

- Hike to the top of Mount Lee and look down at the Hollywood Sign
- Stand where James Dean once tussled in *Rebel Without a Cause*
- Climb aboard the locomotive that pulled President Truman along his whistle-stop campaign tour in 1948
- See outlaw Billy the Kid's rifle, as well as items belonging to lawman Pat Garrett—the man who gunned him down
- Glimpse a rare California condor inside a zoo and keep on the lookout for a wild coyote outside
- Stand on a peak and turn in a complete circle, taking in the view of nearly all of L.A.'s 500 square miles

All of these things, and dozens more, can be accomplished at only one place on earth: Los Angeles' Griffith Park.

For 115 years, Griffith Park has been L.A.'s playground. Generations of Angelenos have jogged its trails; hiked its hills; ridden horses and bikes along its paths; picnicked under its trees; played soccer, cricket, and baseball on its fields; camped within its forests; cheered at its concerts; explored the heavens from its observatory; golfed on its links; ogled exotic animals inside its zoo; swam in its pool; played tennis on its courts; climbed aboard its miniature train and merry-go-round; admired its Christmas lights; and yee-hawed with the cowboys in its museum.

Not unlike the city it serves, Griffith Park is a collection of contradictions. Each year, 12 million visitors pass through its gates, yet it can still provide solitude for the lone hiker. Griffith Park is the main municipal playground for a city that was built around the automobile, but the majority of its 4,310 acres are accessible only on foot, bicycle, and horseback. And while some visitors come to the observatory to learn about stars of the celestial realm, others visit the Greek Theatre to see the earthbound variety.

It's been called "L.A.'s Central Park," and it's often measured up against other Californian municipal showplaces like San Diego's Balboa Park and Golden Gate Park in San Francisco. But in reality, it's much more mountainous and untamed than its Manhattan counterpart and is nearly twice as large as the two competing California parks combined.

In truth, there's no place quite like it.

Griffith Park is the geographical and spiritual heart of L.A., located six miles north of downtown at the eastern end of the Santa Monica Mountains. It's bordered on the north and east by freeways, and by the districts of Los Feliz to the south and Hollywood to the west.

It is, in effect, many parks—each with the ability to fulfill a different purpose.

For those seeking solitude, a visit can be a rejuvenating escape to a mountainous, chaparral- and forest-covered oasis, which, while surrounded on all sides by urban encroachment, still feels plucked from a more serene setting.

It's also a gathering place for crowds, both large and small. It can host thousands of concert-goers at the Greek Theatre, while simultaneously entertaining dozens of smaller groups on-hand to celebrate a reunion, graduation, or birthday.

The park is also a place of exploration, where visitors can experience the thrill of an old-time calliope ride, climb aboard a vintage steam locomotive, or learn about the intricacies of the Crab Nebula at a world-famous observatory.

Film buffs are drawn to the park to see the spots where legendary actors once plied their trade. Lovers of Westerns flock to the Autry National Center to see impressive displays of actual film props used in classic films of that genre.

Animal lovers come to see the exotic creatures that live inside the Los Angeles Zoo. But a paid admission to the menagerie isn't always required to encounter wildlife in the park. Visitors often see deer, coyotes, opossums, and the occasional bobcat within the grounds.

Some visitors come to engage in a wide variety of sports, like golf, soccer, biking, and tennis. But perhaps the most popular activity that takes place here is the mental and physical rejuvenation that comes from taking a break from the congestion and pace of life that lies just beyond the park's perimeter.

The first human inhabitants of the area were Native American peoples known as the Tongva. Their legacy lives on in the names of many native plants and modern places, like nearby Cahuenga Pass.

Europeans first arrived in January 1776, when a party of soldiers and colonists from Mexico, led by Juan Bautista de Anza, camped here en route to establishing the city of San Jose. One of the soldiers on the trek was Cpl. Jose Vicente Feliz, who was awarded the coveted piece of land that would later become Griffith Park by the Spanish crown around 1800. The parcel covered more than 6,000 acres, stretching between the Cahuenga Pass on the west and the Los Angeles River on the north and east.

Rancho Los Feliz, which was named after his family and literally means "the happy ranch," became an unhappy place for the family after Mexico declared its independence from Spain in 1821. The change in government, along with the death of Jose, created ownership problems for his heirs.

The rancho passed into the hands of his widow, who in turn willed it to her son Antonio in 1853. On Antonio's deathbed a decade later, legend has it that his heirs were cheated out of their inheritance by a crooked politician and his attorney. Their swindle allegedly prompted his blind 19-year-old niece Petranilla to deliver a curse on the men—and by extension on all future owners of the land—after which she was said to have punctuated the pronouncement by dropping dead.

The story of the "Petranilla Curse," which is most certainly untrue, has grown over time through retelling to include tales of ghostly sightings of Antonio and Petranilla. It's still occasionally employed (with tongue placed firmly in cheek) to give cause to any unexplained event that happens inside the grounds.

In 1882, the land passed into the hands of Colonel Griffith J. Griffith.

Griffith stands as one of the most colorful and controversial characters in Los Angeles history— which is saying a mouthful. He was born to a poor family in Wales in 1850 and left for America 16 years later. He studied journalism in New York, after having lived for a time with a kindly Pennsylvania couple who had recently lost a son in the Civil War.

Griffith soon found himself in San Francisco, where he quickly became the leading mine reporter on the West Coast. He used the knowledge he gained in his new field to invest in silver mines in Mexico, which earned him his first fortune.

By 1882, Griffith was in Los Angeles where he paid $50,000 for the 4,071 acres that remained of the old Rancho Los Feliz. He settled into the role of a gentleman rancher, growing crops and raising sheep, horses, dairy cows, and ostriches.

Griffith later became a money-lender and land developer in nearby Los Angeles, where he was initially a popular figure for his philanthropy but was increasingly seen as an eccentric egomaniac.

He began using the apocryphal title of "Colonel" during the 1880s—the same decade that he married Tina Mesmer, a woman whose father owned one of the leading hotels in the city.

The marriage, which produced a son named Van in 1888, nearly ended in October 1891, when a former tenant shot Griffith in the face before turning the gun on himself. Griffith survived the shooting with only slight injuries (but the assassination attempt portended grim future events).

On December 16, 1896, the 46-year-old Colonel Griffith presented Los Angeles with a gift of 3,015 acres of Rancho Los Feliz, valued at $300,000. The Colonel wanted to create the largest city park in the world for the people of Los Angeles—a city he believed would soon become one of the great metropolises of the world. He asked only that rail fares be kept to a nickel so poor people could afford to enjoy the new park, and that the grounds be named after him. His true motives for donating the land were seen by some as a grand act of charity and by others as a tax-saving measure or perhaps a bold scheme to make his adjoining properties more valuable.

Los Angeles only had a population of 110,000 in 1896, and the parkland he donated was outside the city limits. The city only agreed to accept the gift after the Colonel added an additional parcel to his proposed original grant, which gave L.A. coveted water rights to the Los Angeles River.

For the next several years, no one in the city could agree on what to do with their gift; there was talk of building hotels, a national arboretum, and a railway link from the park to the city (the grounds wouldn't be annexed by Los Angeles until 1910).

Thanks to his donation, the Colonel was, for a time, a highly regarded figure around town, and he worked as a park commissioner to ensure that Griffith Park would be developed to his liking.

All of this goodwill was lost forever on September 3, 1903. On that day, Colonel Griffith and his wife, Tina, were vacationing at a hotel in Santa Monica. In a drunken state of insanity, the Colonel accused her of trying to poison him under orders from the Pope (Tina was devoutly Catholic; the Colonel was a Protestant). He took aim at her with a pistol and fired one shot, which severely disfigured her face, costing her an eye. Before he could fire again, she jumped out of a window, landing on a roof one floor below, where she was carried to safety.

After the Colonel's arrest, it was discovered that he was a closet alcoholic, consuming an average of two quarts of whiskey each day. After a circus-like trial, he received a two-year sentence in San Quentin and a $5,000 fine. After his release, he worked as staunchly on a new crusade as he had previously toiled developing his park. His new campaign: prison reform.

The Colonel spent the rest of his life trying to rehabilitate his reputation, but the damage was done. The city refused additional donations from Griffith that were intended for improvements to the park, only accepting the money from a trust fund after the Colonel's death in 1919.

These improvements included the purchase of additional land, the creation of golf courses in the 1920s, the construction of both the 5,900-seat Greek Theatre in 1930, and the iconic Griffith Observatory, which was completed in 1935. Camping and hiking became common activities, aided in large part by shade created by a massive reforestation program begun by Griffith's son Van, which turned the chaparral-covered hills into wooded forests.

Much of the construction in the park during the Great Depression was carried out by thousands of unemployed workers, who created many of the trails and much of the infrastructure that is still visible today. Tragedy struck in 1933 when 29 of these men were killed by a rapidly-advancing brushfire that also claimed the original clubhouse at one of the park's golf courses.

The controversial Griffith Park Zoo opened in 1912 and closed in 1966. The Los Angeles Zoo, a new 133-acre, state-of-the-art facility, opened that same year.

Over the years, the Colonel's prophecy about the rapid expansion of Los Angeles proved prescient, and the park soon found itself in the midst of the city, rather than on its outskirts. It also began to serve functions that were sometimes contrary to its primary role as a public recreational area.

For a time, the level plain surrounding what is now the Los Angeles Zoo served as an airport and later a National Guard Air station. After its closure, it became a temporary settlement for thousands of soldiers returning from World War II.

During the Depression, the area that now houses the outdoor locomotive museum called Travel Town served as a Civilian Conservation Corps camp and was later the site of a prisoner-of-war facility during World War II.

In the 1950s, someone in city hall thought it would be a good idea to create L.A.'s largest landfill in Toyon Canyon, where dumping continued until 1985. That same decade, a 2.4-mile strip of land on the park's eastern edge was lost to the 5 Freeway.

Over the years, equestrian activities, ranging from pony rides to professional polo matches, have taken place inside the park. Other outdoor activities, like swimming, cricket, tennis, and golf on one of the park's five courses, have been mainstays.

Trains have been a big part of the Griffith Park experience since the 1948 opening of the miniature Griffith Park & Southern Railroad at the park's southeast corner. On the opposite side of the park, the following decade witnessed the debuts of Travel Town and the neighboring miniature train yard known as Los Angeles Live Steamers. Together, they have provided nearly 60 years of thrills for railroad historians and hobbyists.

The Old West took up permanent residence inside Griffith Park in 1988 when singing cowboy Gene Autry and his wife, Jackie, brought the Autry National Center here. This 140,000-square-foot facility houses three museums: the Southwest Museum of the American Indian, the Institute for the Study of the American West, and the Museum of the American West.

Much has changed in Los Angeles since 1896 when the eccentric, yet philanthropic, Colonel Griffith donated the original parcel of land to the city to create the grand park that now bears his name. During this time, the city grew forty-fold, changing from a sleepy municipality of 110,000, into a booming metropolis of more than four million. The city's chief mode of transportation also changed from horseback, to red car, to the automobile. What were once dirt paths morphed into streets and later into freeways, and the Los Angeles River—once wild and untamed—now borders the park as a paved flood channel.

Today, in spite of competing interests, governmental involvement ranging from disinterest to micro-management, and disasters—both natural and man-made—Griffith Park remains.

This fact can largely be attributed to the foresight of a colorful and controversial immigrant with the redundant name of Griffith J. Griffith, who once said that "public parks are a safety valve of great cities and should be made accessible and attractive, where neither race, [nor] creed, nor color should be excluded."

One hundred and fifteen years after the Colonel's endowment, his words ring true now more than ever.

—E.J. Stephens and Marc Wanamaker
2011

One

THE COLONEL'S GRAND GIFT

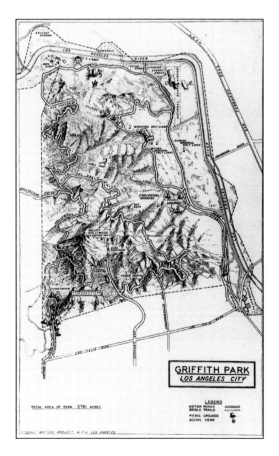

GRIFFITH PARK, 1930S. This map was created as part of the Depression-era Federal Writer's Project in the late 1930s. At that time, an airfield was located at the park's northwest corner. This site later became a temporary city for thousands of returning World War II veterans. Today, it houses the Autry National Center and the Los Angeles Zoo. The recently completed Griffith Observatory and Greek Theatre are visible in the southwest portion of the park. (Courtesy Los Angeles Public Library Photo Collection.)

COLONEL GRIFFITH, 1890S. Griffith J. Griffith was born into a poor farming family in Wales in 1850. He hopped a boat to America at age 16 and studied journalism in New York. In 1878, Griffith became a mining correspondent for a San Francisco newspaper and used the knowledge he gained to make his own mining investments, which netted him a fortune. In 1882, Griffith moved to Los Angeles, where he purchased the Rancho Los Feliz and got married. On December 16, 1896, Griffith, who had begun using the dubious title of "Colonel," presented Los Angeles with a "Christmas gift" of 3,015 acres of his ranch to be used as a city park. The Colonel, who was generally respected by the citizenry—if never completely embraced—became a pariah after shooting his wife during an inebriated fit in 1903. After two years in San Quentin, he tried to rehabilitate his reputation by building the Griffith Observatory and the Greek Theatre, but there were no takers. These structures were later built using funds willed by the Colonel, long after his death.

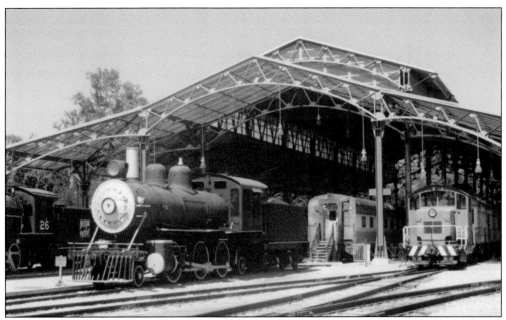

EARLY INHABITANTS. The first human inhabitants of the area that later became known as Griffith Park were Native American peoples known as the Tongva, whose language can still be heard in the names of many native plants and modern places, like nearby Cahuenga Pass. In January 1776, Europeans first stepped foot here when a party of soldiers and colonists led by Juan Bautista de Anza camped in what is today the park's northern end. Cpl. Jose Vicente Feliz, one of the soldiers on the trek, was awarded the land around 1800 by the Spanish government as payment for service to the crown. This modern image of the train pavilion at Travel Town (above) is located near the expedition's campsite. The monument below commemorates the De Anza Expedition and is located at the Pecan Grove Picnic Area.

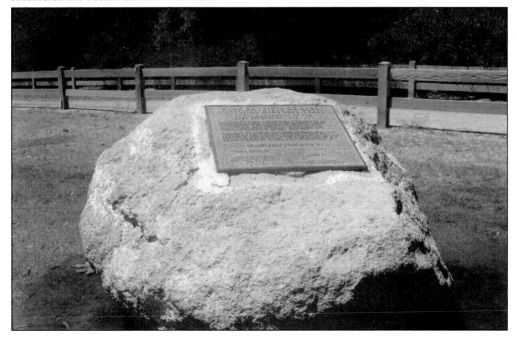

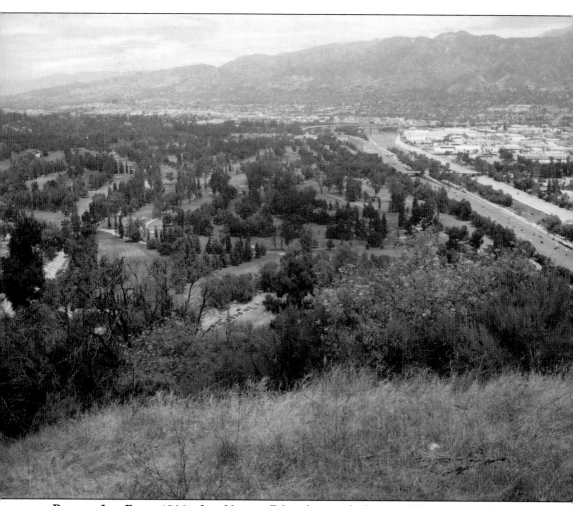

RANCHO LOS FELIZ, 1800S. Jose Vincent Feliz, along with the rest of the De Anza Expedition, made it to San Francisco in March 1776. Five years later, Feliz became one of the first Europeans to arrive in Los Angeles, where he became an official. Around 1800, he was granted 6,647 acres of land north of the pueblo, stretching from the Cahuenga Pass on the west to the Los Angeles River on the north and east. Feliz named his new spread Rancho Los Feliz after his family name, and because it means "the happy ranch" in Spanish. By all accounts, the ranch was a happy one during the next several years until the death of Feliz, which came around the same time as Mexico's independence from Spain. Mexican rule was initially resented by many, and governmental soldiers once had a standoff with armed locals at Rancho Los Feliz. This modern photograph, taken from the top of Beacon Hill looking north, shows the golf courses that now inhabit what was once the main part of Rancho Los Feliz.

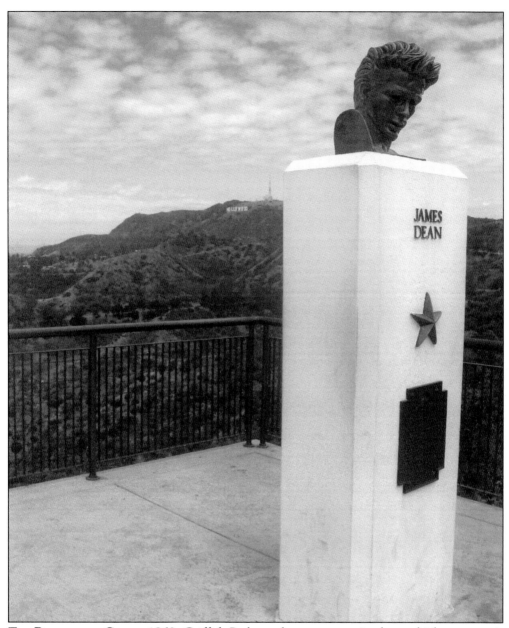

THE PETRANILLA CURSE, 1863. Griffith Park can be a pretty eerie place, which some say is because the ground is actually cursed. One version of the curse legend (which should be taken with a Griffith Observatory–sized grain of salt) begins in 1863, when Antonio Feliz died and the land was swindled away by a neighbor and his crooked lawyer, leaving his blind niece Petranilla destitute. Petranilla placed a curse on the property, which she punctuated by promptly dropping dead. Colonel Griffith later bought the land and created an ostrich farm there, managed by a man named Frank Burkett. Burkett became so enraged when the Colonel later closed the farm, that he shot him before turning the gun on himself. Griffith survived, and a few years later, he shot his wife—who also survived—and spent two years in prison for the crime. Another supposed victim of the Petranilla Curse was James Dean, who was killed shortly after filming here. Today, Dean's statue stands outside the Griffith Observatory.

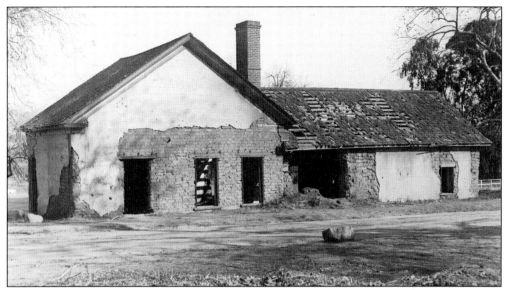

ADOBE BUILDINGS, 1920s. This adobe home (above and below) at Crystal Springs once belonged to the Feliz family. The house was built in 1853 by Jose Paco Feliz, and by the 1920s, the building had fallen into disrepair. It was rumored to be a speakeasy during Prohibition and was in danger of being demolished. It was repaired in 1934 and is used today as the park's film office. A second structure, the main Feliz ranch house, was also constructed out of adobe and was, for a time, the headquarters of the Aero Club that operated in the park. It was razed in 1921.

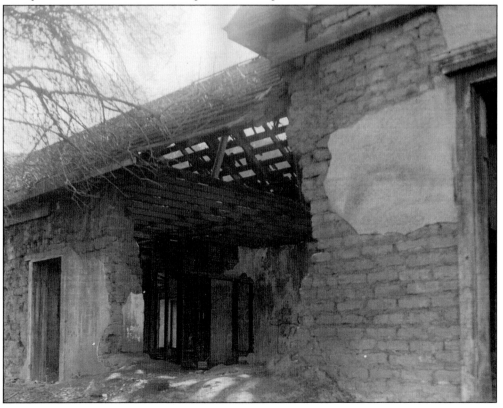

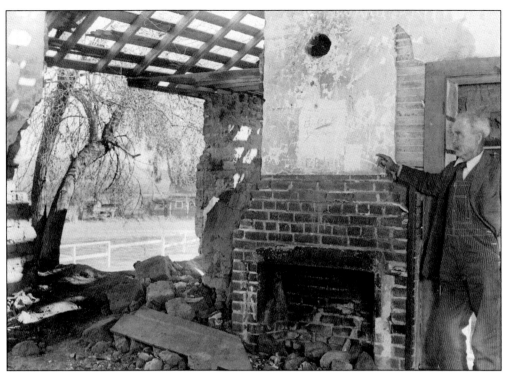

FELIZ ADOBE, 1920s. In the above photograph, James Moore points out the adobe's dilapidated condition. At the time, Moore lived near the adobe and was hoping to get the home repaired and preserved by the city. Below, the adobe is seen in this still from a Charles Ray film. Ray was a popular silent actor whose career cooled off in the 1920s due to the loss of his youthful good looks and his oversized ego. He ended up passing away from an infected tooth at the age of 52.

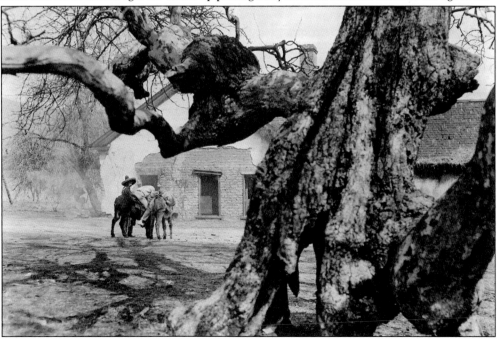

FERN DELL, 1920s. In the 1910s, the park gained an entrance off Western Avenue when the city acquired a corridor 200 feet wide and 1,000 feet long. The strip came to be known as Fern Dell, thanks to the ferns that inhabit the area around a natural spring. Over the next decade, Fern Dell became one of the most popular areas of the entire park. In later years, the area was nearly destroyed by tourists snipping fern plants. In the above photograph, two male visitors stroll through the lush, semitropical fauna, while below, actresses prance among the foliage in this still from an untitled 1920s Fox Film Corporation production.

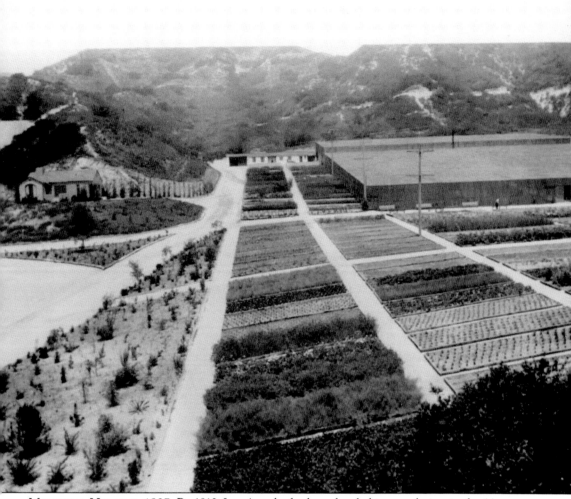

MUNICIPAL NURSERY, 1927. By 1910, Los Angeles had quadrupled in population in the 14 years since Colonel Griffith first donated the land. Many of the new residents came from areas formerly outside of the city that had been annexed. On February 18, 1910, Griffith Park was similarly annexed, and now that his park was within the city limits, Colonel Griffith pushed for more spending from the city for improvements. For the next few years, these improvements progressed in fits and starts, which gave the park new roads, better law enforcement, and a bus line managed by Griffith's son Van. After Van became a park commissioner in the early 1920s, he put a plan in motion to reforest the grounds. The program began in earnest, and by 1927, this nursery in Commonwealth Canyon was stocked with more than two million plants, which once replanted, forever changed the face of the park.

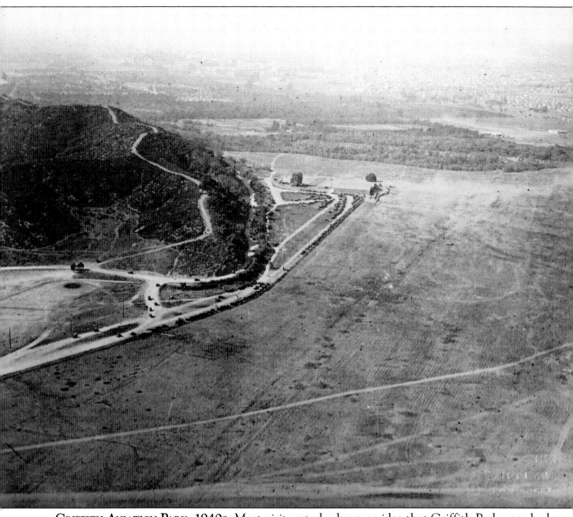

GRIFFITH AVIATION PARK, 1940s. Most visitors today have no idea that Griffith Park once had an airfield. Colonel Griffith held onto a 351-acre, table-flat plot of land for himself at the park's northwest corner, which he called the Griffith Reservation. The Colonel's son Van, an aviation enthusiast, created an airfield on the Griffith Reservation in 1911. The unpaved field had a handful of hangars where some of the founders of modern aviation once worked, including William Boeing, Donald Douglas, and Glenn Martin. Martin set several flying records here and used it as a launch pad for some of the first aerial motion picture photography. A great promoter, Martin made sure that his sponsored stunts hit the papers, including a leap made by Georgia "Tiny" Broadwick over Griffith Park on June 20, 1913, making her the first woman ever to skydive. The airfield closed with Martin's departure in 1916. Between 1925 and 1942, it was used by the California National Guard. Today, the former airfield is covered by the Los Angeles Zoo, the Autry National Center, soccer fields, and a freeway interchange.

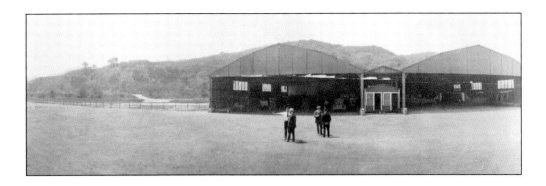

GRIFFITH AVIATION PARK AND GRAND CENTRAL AIRPORT, 1920s. This photograph (above) from 1925 shows the recently reopened Griffith Park airfield, which was then a California National Guard facility. Maj. Corliss C. Moseley ran the field and acquired these two hangars from the mothballed March Field near Riverside. The unit stationed in Griffith Park served primarily as aerial photographers, but they occasionally engaged in combat games. The base closed down nine months before the Japanese attack on Pearl Harbor. The California National Guard airfield was not the only airport in the neighborhood. Just across the river was the much larger Grand Central Airport in Glendale (below). Charles Lindbergh, Amelia Earhart, and Howard Hughes regularly flew here, and Major Moseley created a flight academy at the airport whose graduates fought in the Battle of Britain more than a year before America's entry into World War II.

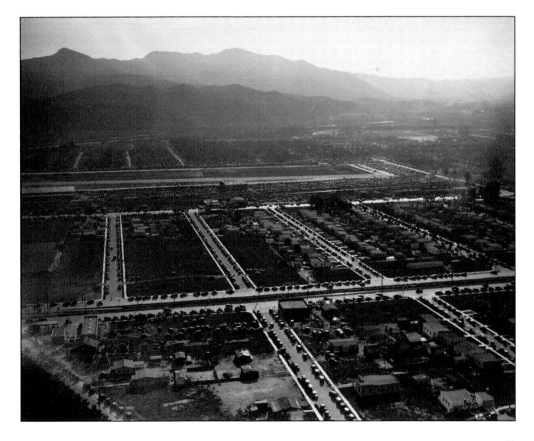

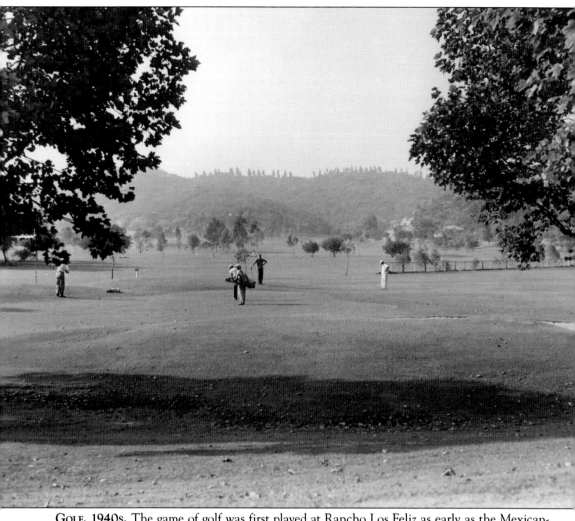

GOLF, 1940s. The game of golf was first played at Rancho Los Feliz as early as the Mexican-American War (1846–1848), when an American general who occupied part of the rancho during the war built a private course on the grounds. In 1900, Riverside Course, the first public golf course in the park, opened with dirt fairways and sand greens. Golf's popularity grew so much over the next two decades that a new 18-hole course was created on the former Griffith Reservation, which the city purchased in 1921. A second course, which was named the Woodrow Wilson Golf Course, opened in 1923 (and is seen here in 1940). The Riverside Course was closed for a time, reworked, and reopened the following year as the William G. Harding Golf Course.

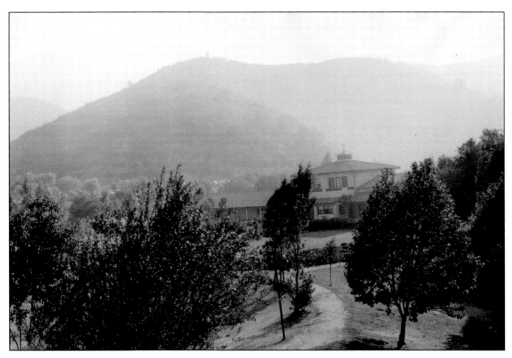

GOLF COURSES, 1940. The photograph above shows the main Griffith Park Clubhouse in the distance. This image, as well as the close-up of its entrance below, was taken by an MGM studio photographer in preparation for a film shoot. This was not the first clubhouse on the site. The original facility was heavily damaged in a tragic brushfire in 1933, which claimed the lives of 29 men pressed into service to fight the fire. The men, who were victims of the Great Depression, were riding out the country's financial hardships by earning money building new roads in the park.

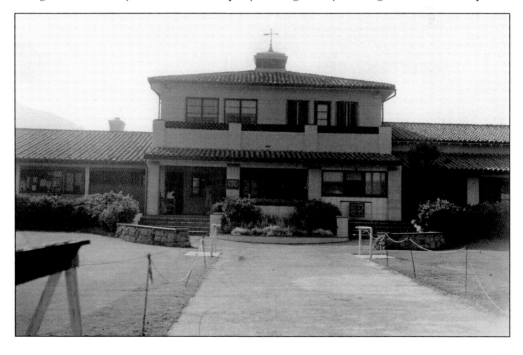

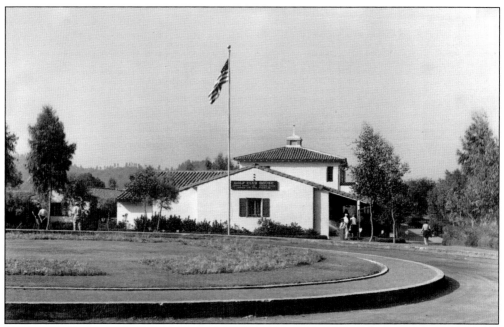

WILSON AND HARDING GOLF COURSES, 1940. These offerings, from the same MGM studio shoot (see page 23), show the side view of the clubhouse (above) and a direction indicator (below). According to Mike Eberts, nearly 275,000 rounds of golf were played in Griffith Park in 1927. Today, there are five golf courses in Griffith Park, three named for presidents (Wilson, Harding, and Roosevelt), as well as the Los Feliz Golf Course and the Marty Tregnan Golf Academy. The golf courses were a frequent setting for motion pictures and regularly hosted celebrities. In 1920, New York Yankees manager Miller Huggins located larger-than-life baseball slugger Babe Ruth on the old Riverside Course and informed him that he had just been traded from the Red Sox to the Yankees.

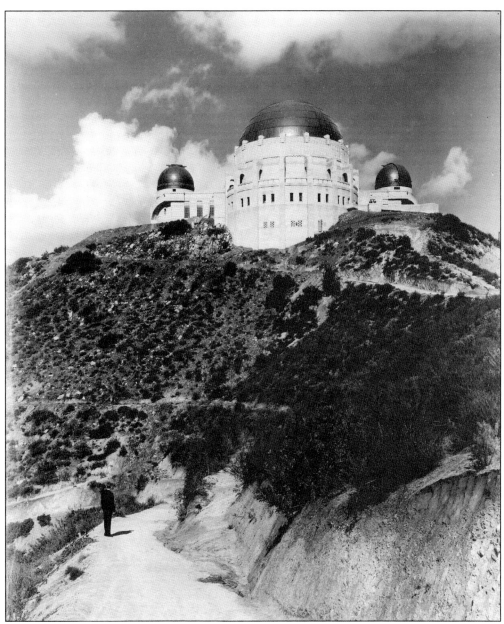

GRIFFITH OBSERVATORY, 1930S. In this photograph from the 1930s, a lone hiker stands below the majestic, recently completed Griffith Observatory. Colonel Griffith offered $100,000 to the city to build the observatory in 1912. The situation had changed drastically from when he had originally bequeathed the land to the city in 1896. This latest gift was being offered by a man who had been imprisoned during the interim for attempting to murder his wife. Perhaps not surprisingly, the money was initially turned down. The observatory was eventually built after the Colonel's death in 1919, from funds he left the city in his will. One of the numerous hurdles that had to be cleared was the choice of its location. The Colonel stipulated in the will that it be built on the peak of Mount Hollywood. This spot proved inadequate, and a different site was chosen lower on the mountainside. This required the city to challenge the Colonel's will in Los Angeles Superior Court. Ground was finally broken on the new observatory in June 1933.

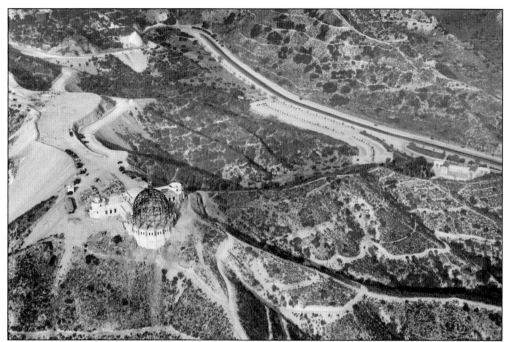

GRIFFITH OBSERVATORY, 1933 AND 1934. The steel skeleton of the observatory's main dome rises in this aerial photograph from December 1933 (above). On the far right is the Greek Theatre, which was completed just over three years earlier. Like the observatory, the funds for the outdoor complex were bequeathed by the Colonel, and this time, they were accepted, but it would still take more than a decade after Griffith's death for the concert hall to open. In the aerial photograph below, taken in October 1934, the observatory's exterior appears near completion, while work on the Astronomer's Monument in the forecourt continues. Aided by the availability of cheap labor and materials during the Great Depression, the entire facility was completed in just over 19 months at a cost of $655,000.

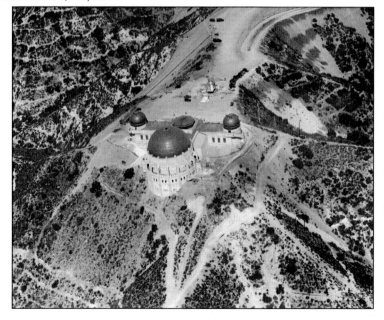

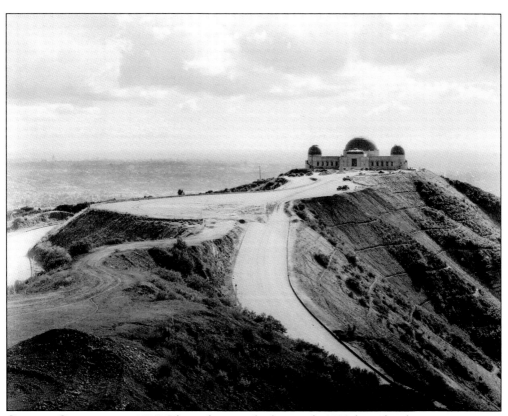

GRIFFITH OBSERVATORY, 1935. These photographs from early 1935 show the observatory nearing completion. The peak of Mount Hollywood proved inadequate for the building because of the insufficient amount of space available at the site for parking lots, among other reasons. Initially, there was talk of building an inclined railway to the peak, but these plans fizzled. When it became clear that automobiles would bring most visitors to the observatory, another site was needed. Extensive grading was required at the alternate site, as seen in the above photograph. Tire tracks run across the ground in front of the building (below) where grass had yet to grow.

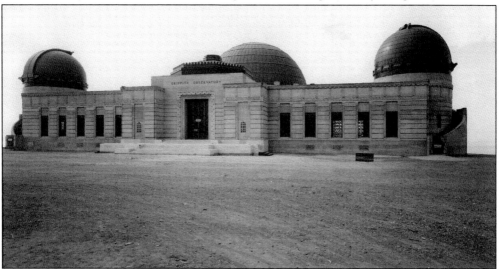

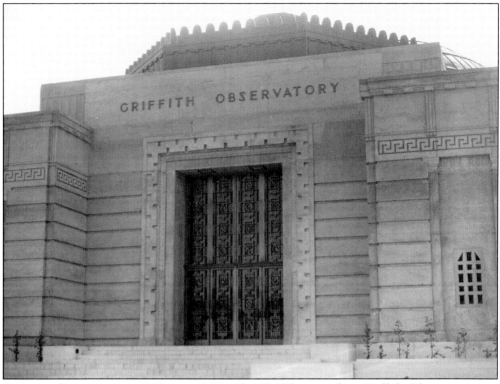

GRIFFITH OBSERVATORY, 1935 AND 1949. The 27,000-square-foot Griffith Observatory was designed by the architectural team of John Austin and Frederic Ashley, who based their plans on the drawings of astronomer Russell Porter. After a major earthquake rocked Long Beach in 1933, the concrete walls were thickened and reinforced. The covering for the three domes also changed when sheets of copper were used instead of ceramic tiles, as originally planned. The above photograph shows the front entrance with its intricate Greek key patterns pressed into the concrete. This aerial shot of the observatory and its grounds (below) was taken in 1949, showing the fully finished facility and mature trees on the hillsides.

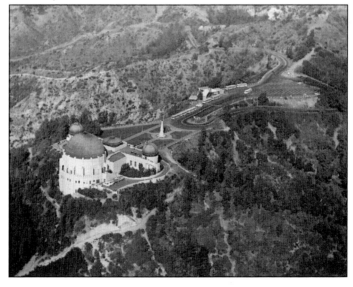

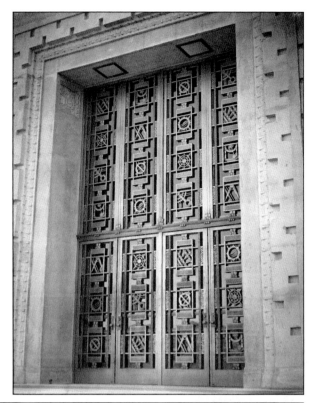

GRIFFITH OBSERVATORY DOORS, 1935 AND 1955. The beautiful bronze-and-glass-paneled front door to the observatory is visible in the photograph on the right. The same door, along with a pleading James Dean, can be glimpsed in this scene from 1955's *Rebel Without a Cause* (below). Of the hundreds of motion pictures filmed here, this is easily the one most associated with the park. All three stars of the film—Dean, Sal Mineo, and Natalie Wood—died tragically at an early age. James perished in a Central California car crash on September 30, 1955, just weeks before the release of the film; Mineo was stabbed to death in a 1976 robbery; and Natalie Wood drowned in 1981.

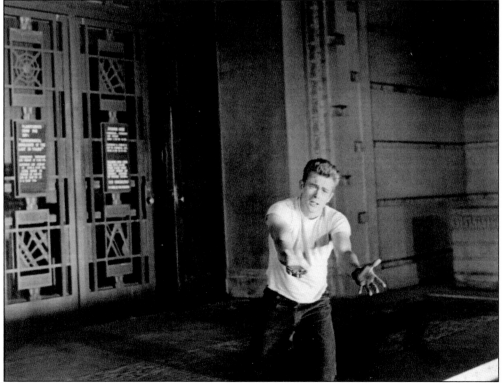

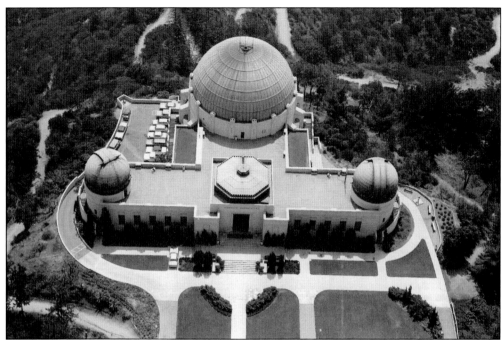

MOUNT HOLLYWOOD, 1949. Griffith Observatory sits on the slope of Mount Hollywood. The mountain—at that time, the highest point in the park—was originally named Griffith Peak, but after the Colonel shot his wife in 1903, it was renamed Mount Hollywood. (Had Griffith not specifically named his bequest Griffith Park in his original donation to the city, its name would undoubtedly have been changed as well.) The Hollywood Sign is not on Mount Hollywood. It is located on the peak next door, which is named Mount Lee. This aerial photograph (above) shows the roof of the observatory with the three copper-topped domes and octagonal section over the foyer. Below is the view from out the front door.

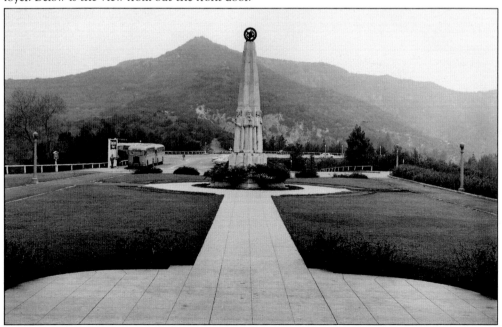

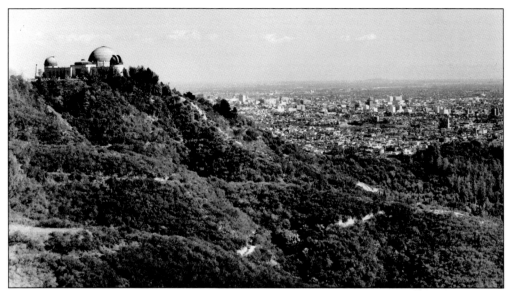

GRIFFITH OBSERVATORY, 1949. Like a lion surveying the Serengeti, Griffith Observatory towers majestically over the Los Angeles basin. Most of the city to the south can be seen from the grounds, and on a clear day, the rugged outline of Catalina Island ("26 miles across the sea") floats on the horizon. When Colonel Griffith donated the land to Los Angeles in 1896, the park was located outside the city limits. As the above photograph from 1949 clearly shows, Los Angeles had crept to the borders of the park during the previous 53 years. The bottom photograph shows the observatory in 1949. The 40-foot-tall, six-sided Astronomer's Monument is visible in the front lawn. This statue honors some of the most important astronomers in history and was created by unemployed sculptors working as part of the Depression-era Public Works Art Project.

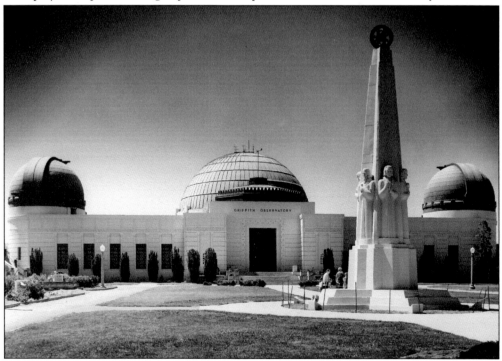

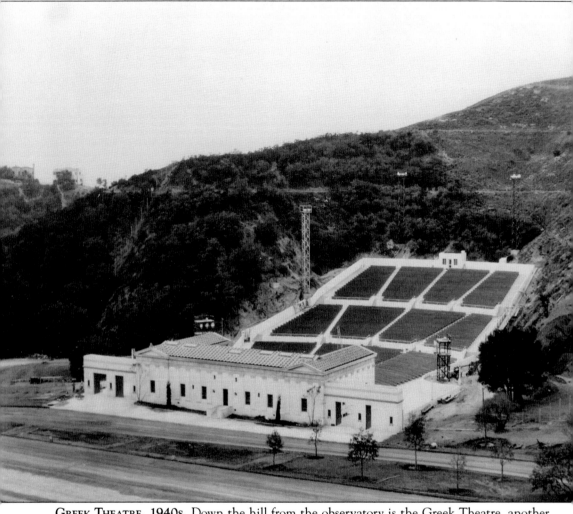

GREEK THEATRE, 1940s. Down the hill from the observatory is the Greek Theatre, another posthumous gift from Colonel Griffith. This 5,900-seat outdoor arena was first proposed by the Colonel in June 1913, at a picnic at the site, which was attended by 500 people. Unlike his proposed donation for the observatory, this time, the city said yes, but competing interests kept the project on ice until a decade after the Colonel's death. Griffith's original concept for the amphitheater was for a 10,000-seat, open-air facility with a stage modeled after a Greek temple. He initially proposed $50,000 for the project (which he later increased to $100,000), but when the time came for the project to commence, costs had escalated to $700,000. A scaled-down version of the theater was eventually built for around $200,000, which was mostly paid for by funds left to the city in Colonel Griffith's will. It opened on September 25, 1930.

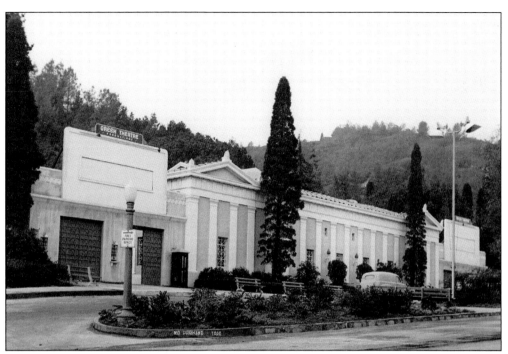

GREEK THEATRE, 1949. Colonel Griffith envisioned building an edifice similar to the Greek Theatre at the University of California, Berkeley. In contrast to his previous donations to the city—which were long on vision but short on details—Griffith's gift came with some strings intended to get the project underway quickly. The city enthusiastically accepted his proposal, and it appeared the theater would be built in short order. Political squabbles between the city and the park commission quickly halted the progress, and the Colonel realized that neither the theater nor the observatory would be completed during his lifetime. To insure that his wishes would be carried out after his death, he created a trust fund for the projects. These exterior (above) and interior (below) photographs were taken in 1949.

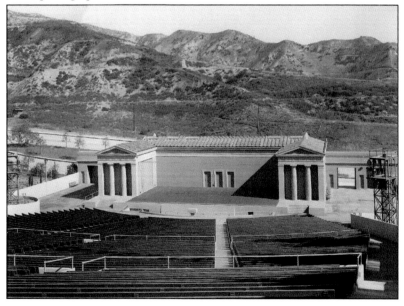

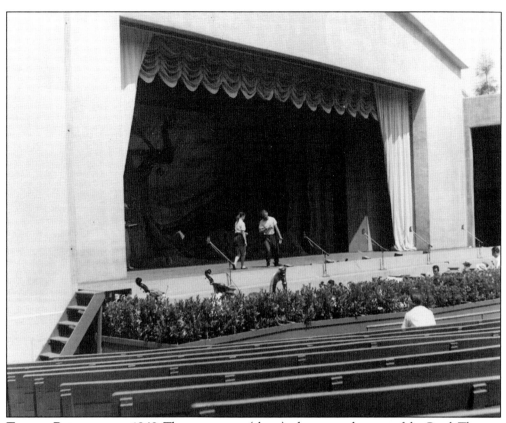

THEATER PREPARATIONS, 1949. These two actors (above) rehearse on the stage of the Greek Theatre, while members of the orchestra and a lone patron look on. The photograph below shows the view of the empty amphitheater from the stage. The layout of the theater was modeled after the Pasadena Community Playhouse and has been the site of dozens of legendary performances over the years. For its first two decades, the theater was underutilized and was made into a barracks during World War II. It wasn't until it was taken over by promoter James Doolittle in the 1950s that the theater came to prominence. Nearly every notable performer has played at the Greek Theatre, where concerts have to end at 10:30 p.m. so as not to disturb residents in nearby neighborhoods.

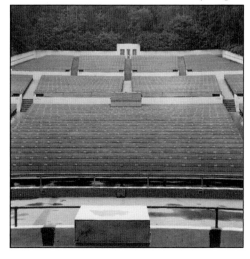

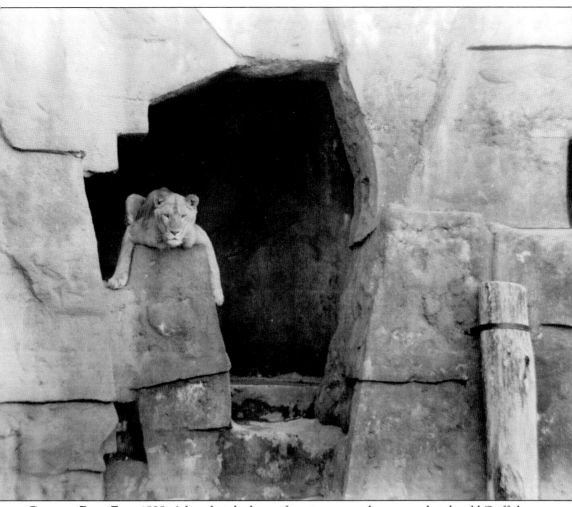

GRIFFITH PARK ZOO, 1939. A lone lion looks out from its cramped compound at the old Griffith Park Zoo. Griffith Park has been a home for zoos since 1912 when the city moved its previous animal collection to the site of Colonel Griffith's former ostrich farm. From the start, the facilities proved woefully inadequate, and for the next two decades, the zoo hovered on the brink of closure. During the Depression, it was renovated and expanded as part of a Works Progress Administration project. The new facilities were not much better than before, and cries for closure continued. By 1958, Los Angeles voters were so fed up with the sorry conditions at the zoo that they approved an $8 million bond issue to create a world-class zoo. Fighting broke out immediately between rival civic groups on where to place the zoo and who was going to run it. Finally, the decision was made to build the zoo on old Griffith Reservation land two miles to the northwest of its previous site. Ground was broken for the new zoo in 1964.

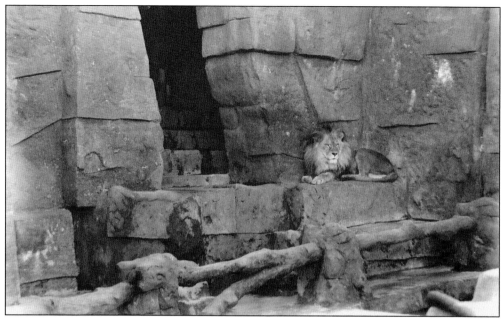

ANIMAL CAGES, 1939. The Griffith Park Zoo was called a "Devil's Island for animals" by some detractors who were appalled by the cramped quarters. Other complaints arose from reports of zoo sewage spilling into the Los Angeles River, a contagious disease that forced the slaughter of most of the big cats, and the decision to feed some of the animals horse meat instead of beef as a cost-cutting measure, which resulted in many deaths. Above is another look at the lion compound in 1939. Below is a photograph of a few of the zoo's animal cages, which some described as "stockades."

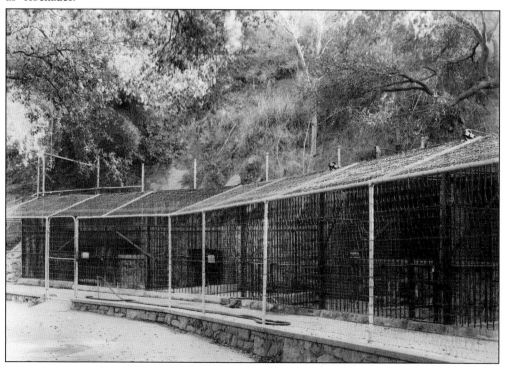

LOS ANGELES ZOOS, 1967 AND 1915. The Los Angeles Zoo (right) was the latest in a line of Los Angeles–area zoos. The city first opened the Eastlake Zoo in East Los Angeles in 1885 and later, the Griffith Park Zoo in 1912. Other private zoos existed as well, including David Horsley's Bostock Jungle & Film Company (below) in downtown Los Angeles. Horsley put on live animal shows for the public and also rented the zoo out to filmmakers to shoot jungle movies.

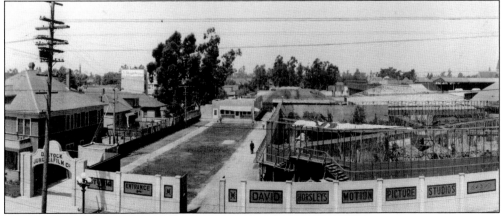

LOS ANGELES ZOO, 1960S AND 1970S. It took years to determine where the new zoo would be located. Certain factions pushed for Elysian Park, some for a site alongside Dodger Stadium in Chavez Ravine, while others wanted to move it to the San Fernando community of Pacoima. After much wrangling, a site was chosen inside Griffith Park, two miles away from the current zoo, at the Roosevelt Golf Course. Construction began on the new zoo in 1964, and the facility opened on December 5, 1966. The Roosevelt Golf Course was later relocated to a spot near the Greek Theatre. The above view of the zoo was taken shortly after it first opened. The bottom photograph shows the completed second phase.

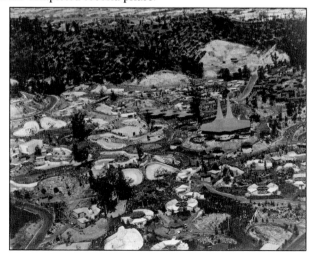

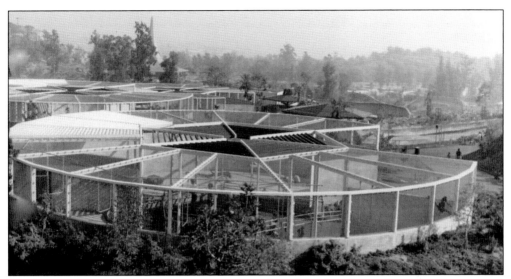

LOS ANGELES ZOO, 1970s. The new zoo was more than eight times larger than its predecessor and eventually became home to 1,100 animals from 250 different species. As shown in the following two photographs, the cages for the animals were much larger at the new facility. The circular cages (above) were built for housing smaller animals. A chimpanzee peers out of the cage at the primate compound (below). Skippy (not pictured), the chimp who starred in several Tarzan films, passed away at the old Griffith Park Zoo on September 27, 1962. He was 34 years old when he died, which is the equivalent of 100 in chimp years. At the time of his death, he was the oldest primate of his kind living in the United States.

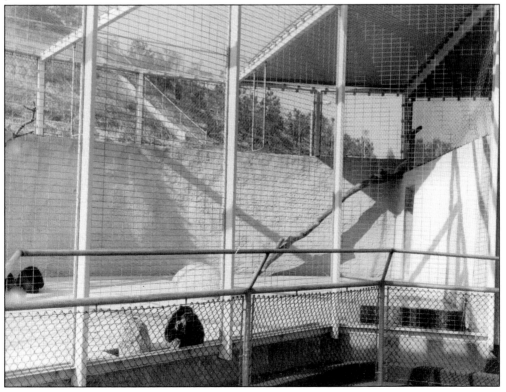

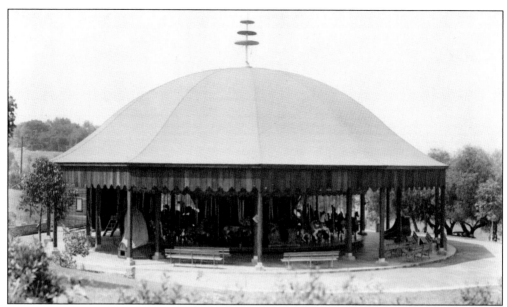

GRIFFITH PARK MERRY-GO-ROUND, 1950s. The first carousel appeared in Griffith Park in 1935. Built by the Spillman Engineering Company, it was a privately owned operation placed near the entrance to the Griffith Park Zoo. It was replaced two years later by a larger carousel (above) at the same spot, which is the one still in use today. This carousel was built by the same company and was used for nearly a decade in San Diego before coming to Griffith Park. Every horse on the calliope is a leaper (below), and some were crafted by legendary artist Charles Looff in the 1880s. Walt Disney was a frequent visitor, and the bench he regularly sat on can be found inside the carousel. When he was first conceptualizing Disneyland, he liked the calliope so much, he asked the owner to find a similar one for his new park. It is still in use there today.

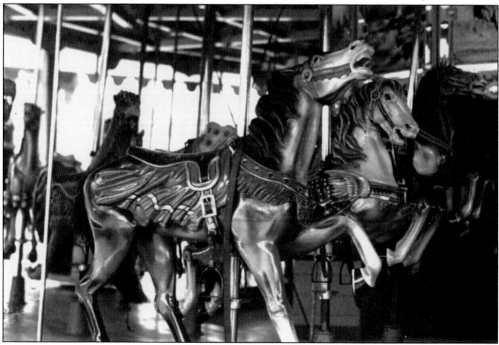

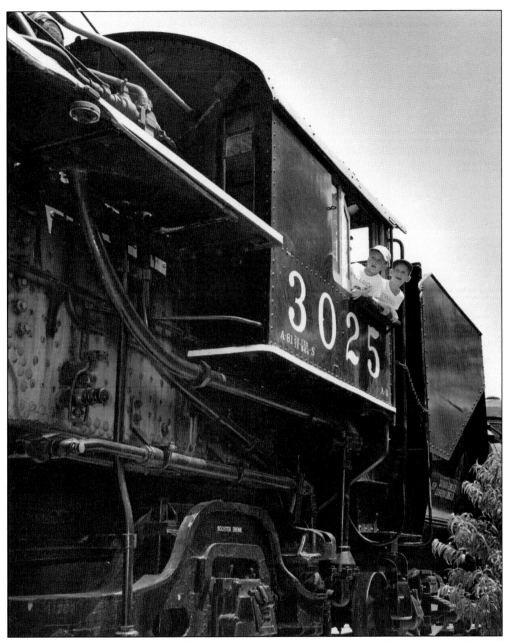

TRAVEL TOWN, 1967. While no railroad ever crossed Griffith Park, several trains are now housed here in Travel Town—an outdoor railway museum in the park's upper-northwest corner. Travel Town sits on a nine-acre site that was once a Civilian Conservation Corps camp during the Depression and later a POW camp in World War II. The museum was the collective dream of city employees William Frederickson Jr. and Charlie Atkins, who saw the end of the steam-train era approaching and wanted to amass a collection of the soon-to-be obsolete locomotives for public display. In September 1952, the team acquired their first engine, a 115-ton, 1904 Southern Pacific locomotive No. 3025 (pictured here). Since then, Travel Town has assembled an impressive array of steam locomotives and rolling stock, representing the history of railroading in the western United States between the 1880s and 1930s.

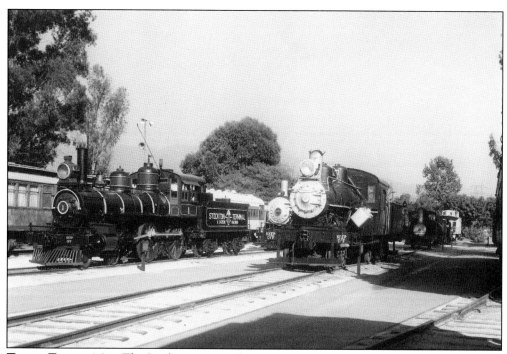

TRAVEL TOWN, 1960s. The Stockton Terminal Eastern locomotive No. 1, a 4-4-2 steam locomotive built in 1864, is with other engines in the Travel Town collection (above photograph, center, and below photograph). Travel Town is not the only train museum in Griffith Park. Next door is the Los Angeles Live Steamers Railroad Museum, an organization that began in 1956 by live steam enthusiasts who create and operate scale-model railroads at the site. In 1965, Walt Disney donated 1,500 feet of track from his own property, which became known as the "Disney Loop." Thirty-four years later, the museum received Disney's Carolwood Pacific Railroad barn—his own miniature railway workplace—that once stood at his Beverly Hills estate.

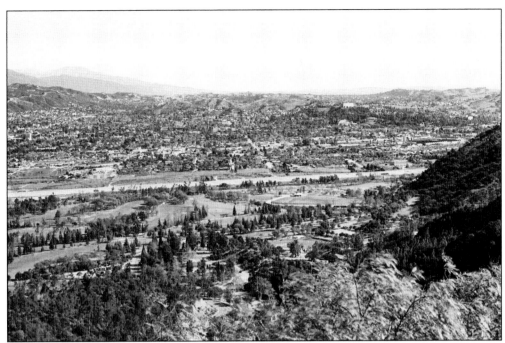

BRUSHFIRES, 1960s. Griffith Park has been blackened by many brushfires, but none were as deadly as the fire of October 3, 1933, that broke out in Mineral Wells Canyon. On that hot afternoon, Griffith Park was filled with thousands of unemployed men who were collecting public assistance in exchange for working in the park. When the fire broke out, foremen sent thousands of the unemployed men forward to fight the flames. The wind shifted, and within seven minutes, 29 of them were killed. The above photograph shows the view from the area where most of the men died. Nearby, these 29 trees (below) line a fire road as a living memorial to the men who died that day in the deadliest fire in Los Angeles history.

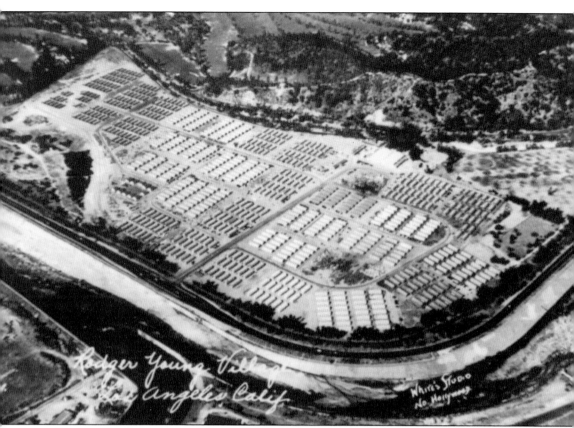

RODGER YOUNG VILLAGE, 1940S. When the GIs returned to Los Angeles after fighting overseas during World War II, many were unable to find adequate housing. To help alleviate the problem, 1,500 Quonset huts were set up on the park's upper-northeast corner. This temporary village quickly grew to a self-contained community of 5,000, complete with its own supermarket, medical facilities, pool hall, ice cream parlor, theater, and library. It was customary for two families to share each Quonset hut, which helped keep the sense of community high. The residents of Rodger Young Village were the most racially diverse community in Southern California. The friendships that developed in the village between racial groups helped to change the policies of segregated businesses in the area. The area where Rodger Young Village was located was formerly the site of the Griffith Aviation Park and a California National Guard air station. The village shut down in March 1954. The site is now occupied by the Los Angeles Zoo, the Autry National Center, the John Ferraro Soccer Fields, and the California 134/5 Freeway interchange.

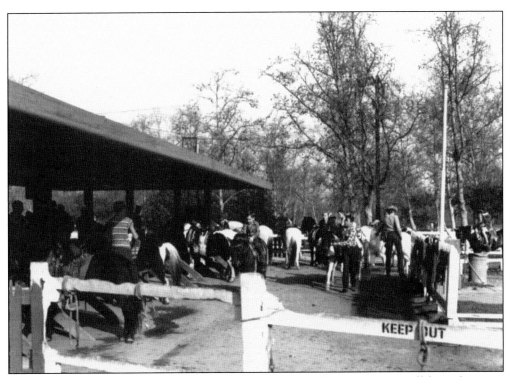

PONY RIDES, 1954. Some of the Griffith Park attractions lie in areas cut off from the main property. These include the Los Angeles Equestrian Center, Bette Davis Park, the John Ferraro Soccer Fields, and the Los Feliz Golf Course. Other points of interest are found at the periphery of the main property. One of the most popular is the pony rides (above), located at the park's far southeast corner, which have been a staple in the park since Tommy T. Wright began operating the attraction in 1946. Equestrian sports are a major activity in Griffith Park. The park boasts more than 50 miles of bridle trails, and on the opposite end of the park from the pony rides attraction is the Los Angeles Equestrian Center. Below, coauthor Marc Wanamaker (center)—complete with cowboy hat—guides his noble steed down a path in 1954.

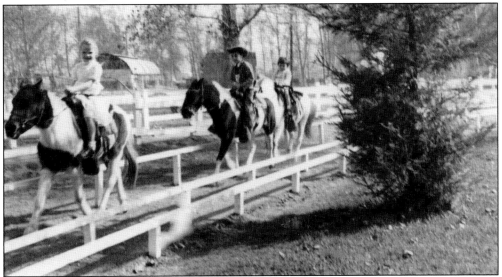

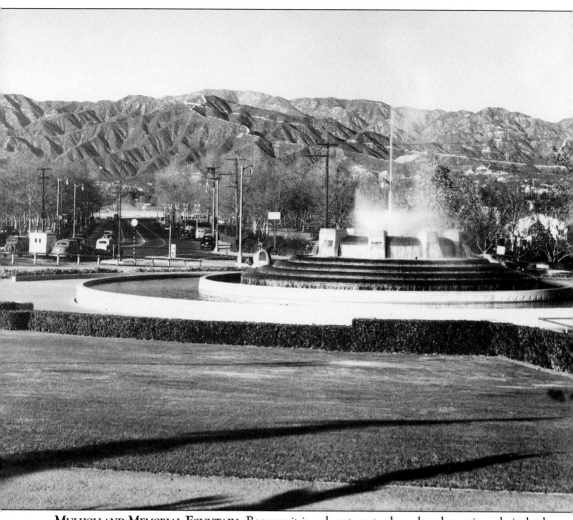

MULHOLLAND MEMORIAL FOUNTAIN. Because it is a desert, water has played a major role in both the history of Los Angeles and Griffith Park. William Mulholland was the man most responsible for bringing the water of Northern California to the parched Los Angeles basin, providing the catalyst for its explosive growth. During his prime, he was undoubtedly the most powerful man in Los Angeles, but his reputation crashed down from that lofty height in March 1928, along with the St. Francis Dam, which he had inspected hours earlier and given his blessing. That night, 450 Californians drowned in the second-worst disaster in California history (only topped by the 1906 San Francisco Earthquake). Mulholland died a broken man in 1935 as a result of the tragedy. Five years later, the people of Los Angeles chose to honor Mulholland by dedicating the Mulholland Memorial Fountain. It was placed at the corner of Riverside Drive and Los Feliz Boulevard, just outside the Griffith Park gates. This spot was the former site of the shack where a young, impoverished Mulholland lived at the time he first began working for the water department.

Two

LOS ANGELES AT PLAY

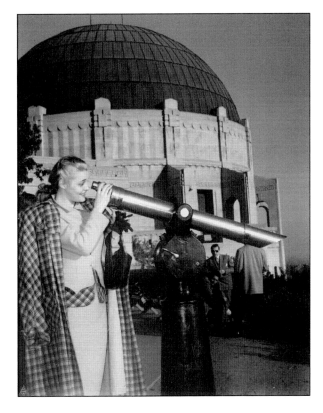

GRIFFITH OBSERVATORY, 1940S.
Someone once said, "We make our
buildings, and then our buildings
make us." The same can be said
for parks. Since 1896, Griffith
Park has been making memories
for the people of the city of Los
Angeles. Here, a woman looks
down at the city from the grounds
of the Griffith Observatory.

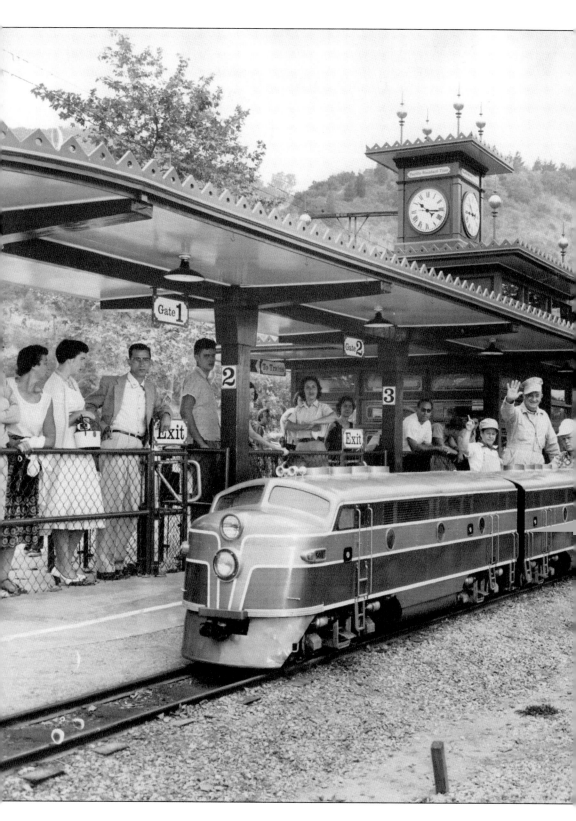

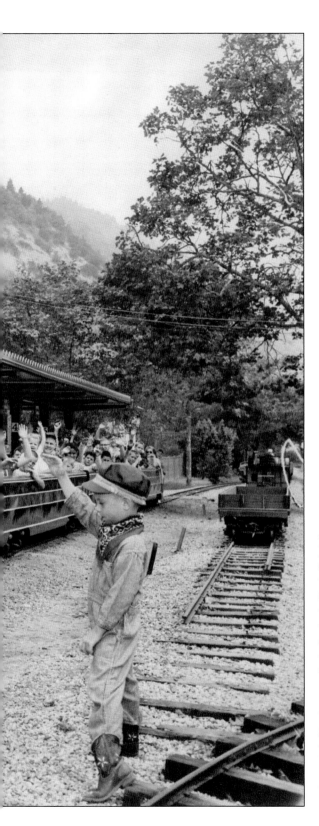

GRIFFITH PARK & SOUTHERN RAILROAD, 1957. Five-year-old Rusty Cuhel gives the "highball sign" to the engineer of the Griffith Park & Southern (GPS) Railroad, indicating that it's okay for the train to leave the station. The GPS Railroad has operated at the southeastern corner of Griffith Park since 1948, running one-third-scale reproductions of classic, 20th-century American trains, like the Freedom Train, seen here. There is approximately one mile of 18.5-inch-gauge rail on the GPS line with a station, passenger loading structure, train barn, tunnel, and bridge. Griffith Park is a multigenerational venue, appealing to tykes like Rusty, as well as to adults like those standing in line.

49

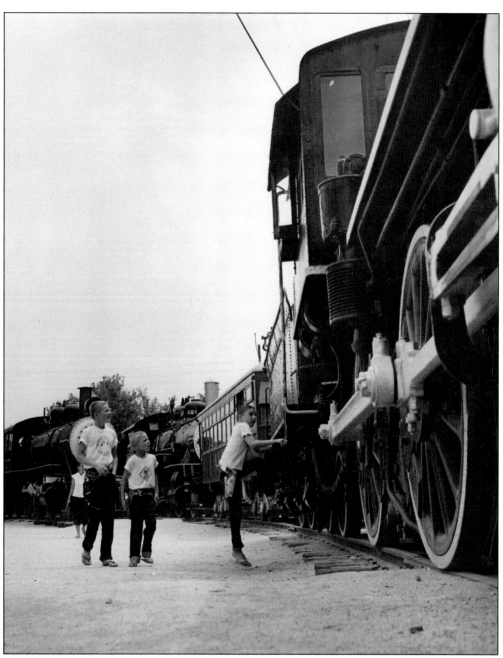

TRAVEL TOWN 1950s. Since its inception in 1952, children have climbed aboard the massive iron locomotives at Griffith Park's Travel Town Transportation Museum. According to the organization's website, the museum was intended from the beginning to be a "railroad petting zoo," where the children of Los Angeles were to "imagineer" themselves as railroad engineers. Walt Disney was a great lover of locomotives and a frequent visitor to Travel Town. When he was assembling his team to design and build Disneyland, he insisted that his new park in Anaheim be circled by a railroad. Is it any wonder that Disney called the crew who developed Disneyland his "imagineers?" (Today, Walt Disney Imagineering, the company that builds and enhances the Disney theme parks worldwide, is located in Glendale, just minutes away from Travel Town.)

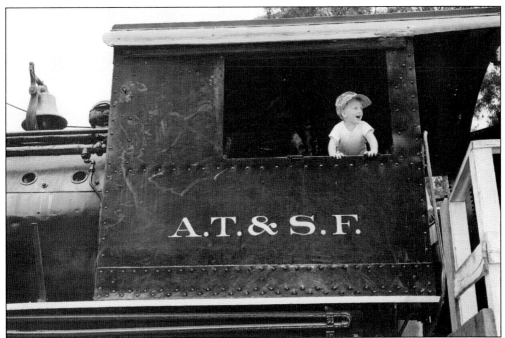

AT&SF No. 664, 1950s. This young visitor (above) "imagineers" himself piloting the Atchison, Topeka & Santa Fe No. 664 locomotive. This train was built in 1899 and has a 2-8-0 wheel arrangement. It was donated to Travel Town in 1953 by the Santa Fe Railroad. Below, the same boy, along with an adult and another youngster, examine the vast array of levers and knobs that once controlled this massive, 70-ton iron horse. Today, Travel Town has one of the largest displays of rolling stock west of the Mississippi River and has a miniature train available for rides.

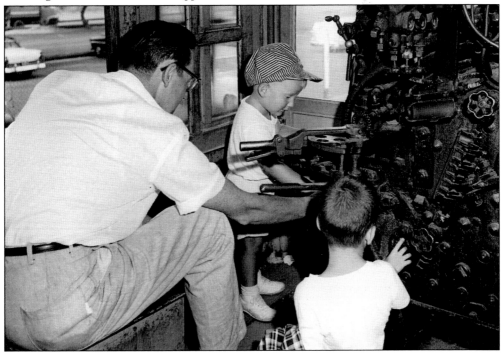

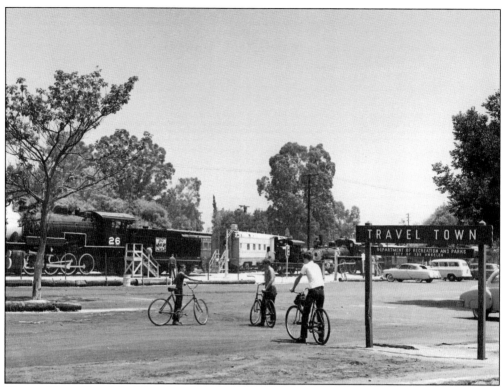

TRAVEL TOWN. Boys bike (above) and run (below) to Travel Town, which rests on a plot of ground at the park's northwest corner. Before becoming a transportation museum, it once was the site of a municipal prison farm from 1918 to 1924, where the prisoners grew crops. During the Great Depression, it became Camp Griffith Park, a Civilian Conservation Corps camp, where the workers stayed at night after spending their days enhancing the park. In 1935, Pres. Franklin Roosevelt and his wife, Eleanor, paid a visit here. During World War II, the site served as a POW camp.

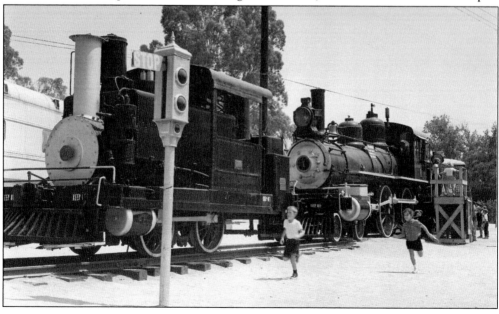

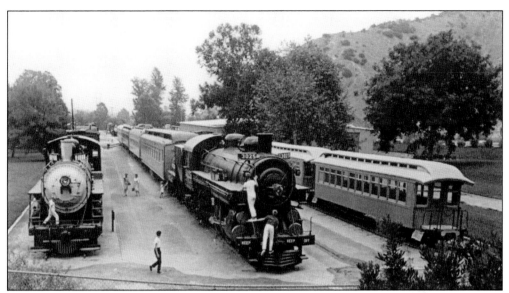

TRAVEL TOWN, 1950s AND 2011. In the above photograph from the 1950s, two men climb aboard the Southern Pacific No. 3025. This locomotive, which was the first item of rolling stock donated to the Travel Town Transportation Museum in 1952, was said to have pulled Pres. Harry S. Truman on his cross-county whistle-stop campaign tour of 1948. Recently, Travel Town has added a large, $1.2-million steel-and-glass pavilion, reminiscent of an old-time train station, to protect some of the historic collection from the elements. Future plans call for a full-sized, two-mile railroad line to be constructed from Travel Town to the Autry National Center and the Los Angeles Zoo. Below, is a modern-day photograph of the Little General, a locomotive modeled after the Civil War locomotive, The General, which Buster Keaton made famous in his 1926 movie of the same name.

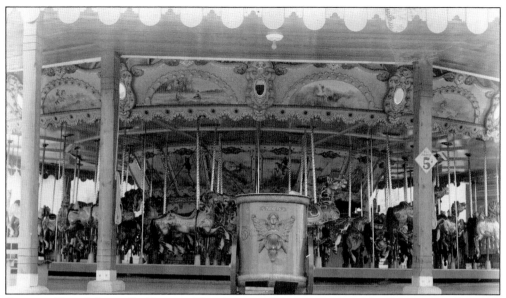

GRIFFITH PARK MERRY-GO-ROUND. This four-astride carousel (above) has been in Griffith Park since 1937. The merry-go-round was placed near the entrance to the Griffith Park Zoo, which closed in the mid-1960s when the new Los Angeles Zoo opened two miles away. Each of the carousel's 68 horses is a leaper and a finely crafted work of art, with jewel-encrusted bridles and beautifully painted blankets. Its music is provided by the largest carousel organ on the West Coast, which plays more than 1,500 waltzes and marches. These photographs were taken when rides only cost 5¢ (today, they are $2). Below, this young lady appears to be getting her nickel's worth.

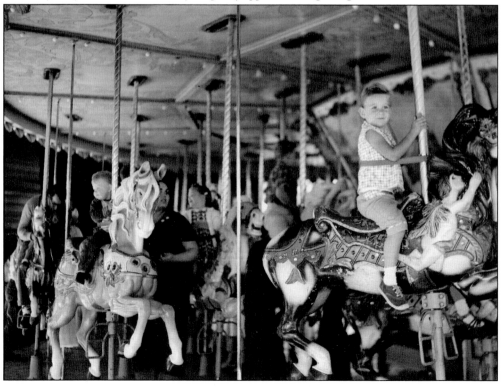

CAROLYN'S "BIG" DAY, 1941.
Because it's located just minutes from the media districts of Hollywood and Burbank, Griffith Park has regularly been used as a location for filming and for promotional shoots. Here, five-year-old child starlet Carolyn Lee and her costar—a St. Bernard named Big—spend a day touring the park while promoting the feature film *Virginia* (1941). In the photograph to the right, Carolyn walks Big (or perhaps, Big walks Carolyn) outside the Griffith Park Merry-Go-Round. Below, the two ride the carousel together. *Virginia* was a clone of *Gone With the Wind* made by Paramount Pictures, starring Madeleine Carroll, Fred MacMurray, and Sterling Hayden. Young Carolyn, who played Pretty Elliott in the movie, only appeared in five films and one television show during her brief career.

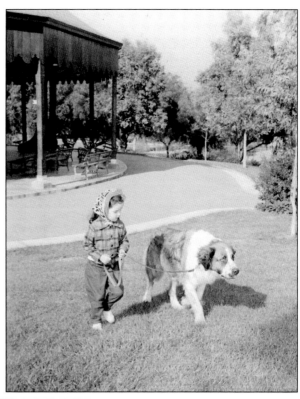

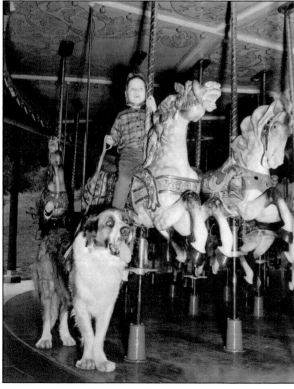

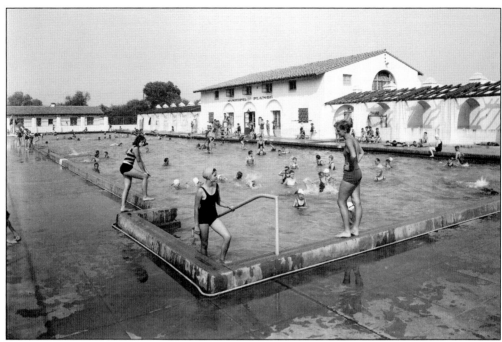

MUNICIPAL PLUNGE, 1935. For several decades, young Angelenos have cooled off in the park's 225-by-50-foot swimming pool called the Municipal Plunge (above and below). The facility was installed in 1927 and is located in the southeast corner of the park. It is part of a 20-acre recreational complex that, over the years, has featured tennis courts, basketball and volleyball courts, and fields for baseball and other sports. Other activities besides swimming have taken place at the plunge, including canoe lessons and water pageants. Once slated for closure, the pool still operates during the summer months.

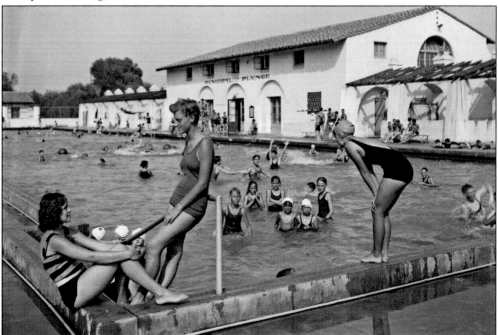

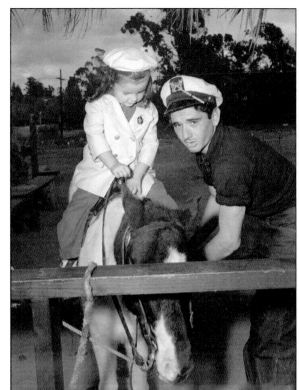

PONY RIDES, 1941 AND 1952. No child's day at Griffith Park would be complete without a pony ride, as witnessed by these photographs from 1941 and 1952. In the photograph to the right, young starlet Carolyn Lee (see page 55) continues her promotional photo shoot atop a pony. Eleven years later, coauthor Marc Wanamaker (below, center) rides along the trail.

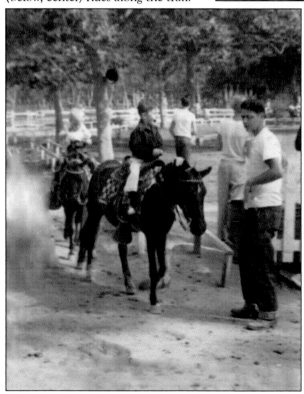

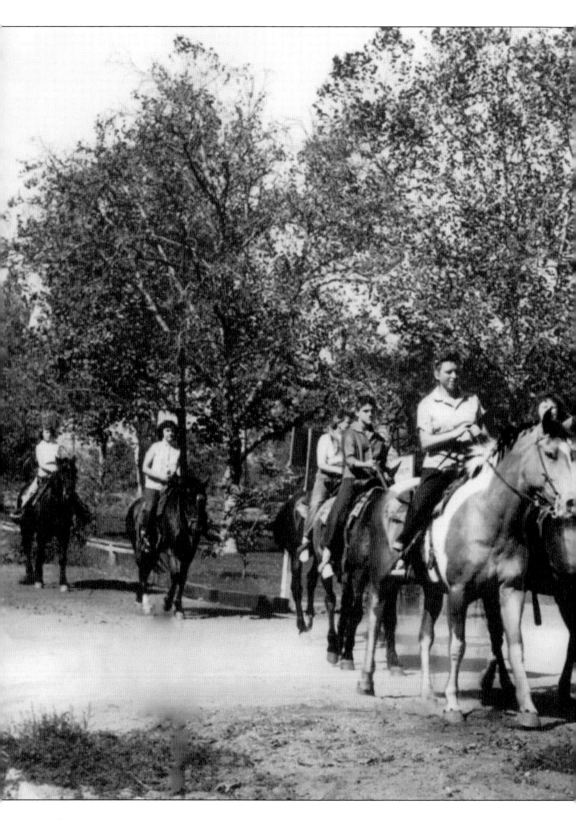

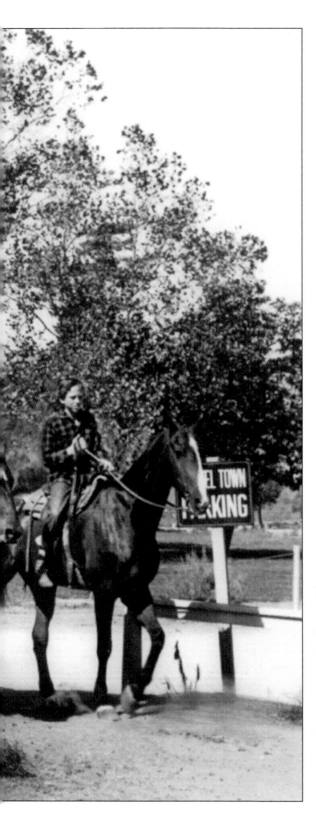

BRIDLE PATHS. There is also horseback riding for "big kids" in the park on more than 50 miles of bridle paths. The Los Angeles Equestrian Center can be found on the north side of the Los Angeles River, adjacent to the city of Burbank. This "equestrian district" of Burbank shares real estate with the Walt Disney and NBC Studios. Over the years, the Equestrian Center has hosted horse shows, jumping competitions, and rodeos. During the 1980s, it was also a prime spot to watch professional polo matches, which were popular with the celebrity crowd.

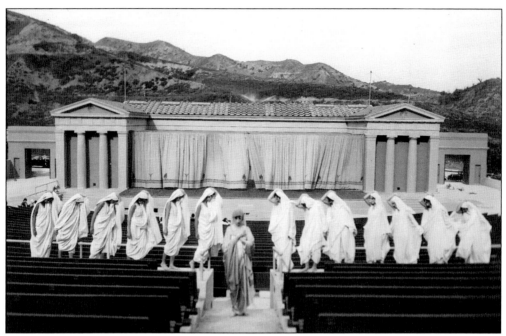

GREEK THEATRE (DAY), 1930S. The Greek Theatre had its grand opening on September 25, 1930, more than 17 years after Colonel Griffith first proposed building the outdoor amphitheater and more than a decade after the Colonel passed away. The opening performance featured a large number of acts, including this group of Greek dancers (above) under the direction of Norma Gould. The bottom photograph, from the amphitheater's early days, shows a scene from a motion picture being filmed from the stage (as denoted by the camera and light deflectors), while a small audience of extras looks on from the benches out front.

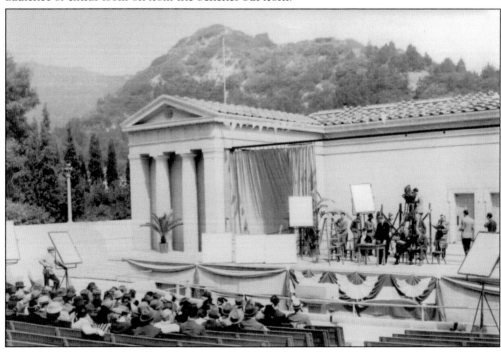

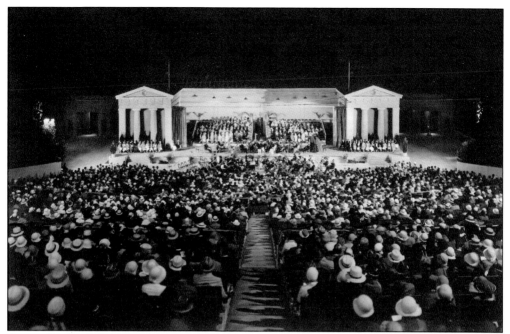

GREEK THEATRE (NIGHT), 1930s. These two photographs are thought to be from the Greek Theatre's grand opening performance in September 1930. As previously mentioned, the amphitheater had a gestation period of more than 17 years from the time the idea was first conceived until the opening-night performance. After the successful opening, the theater went dark for months, and was underutilized for several years. During World War II, it was, for a time, used as a barracks. After its slow start, the amphitheater became a world-class concert hall during the 1950s. In recent decades, many of the most legendary acts in popular entertainment have performed at the theater, including Neil Diamond, who recorded his classic *Hot August Night* (1972) live album here.

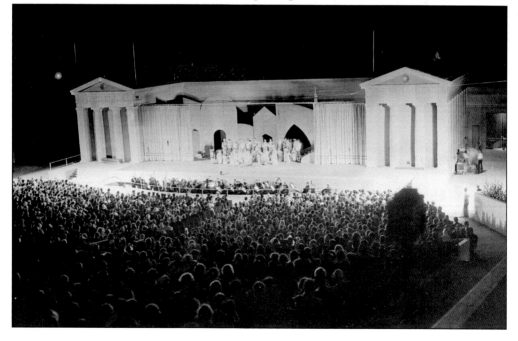

GRIFFITH PARK ZOO, 1944. Despite the inadequate conditions at the Griffith Park Zoo, for decades it was a very popular destination for Angelenos, largely because it had no entrance fee. In these photographs, taken during World War II, guests stroll through the 17-acre grounds past the lion enclosures (above) and the pens that housed smaller animals (below). Calls for the closure of the Griffith Park Zoo began almost from the moment it first opened in 1912. It was enlarged and improved slightly during the Great Depression, but most visitors considered the zoo unworthy of a great city like Los Angeles, and its closure in the mid-1960s saddened few.

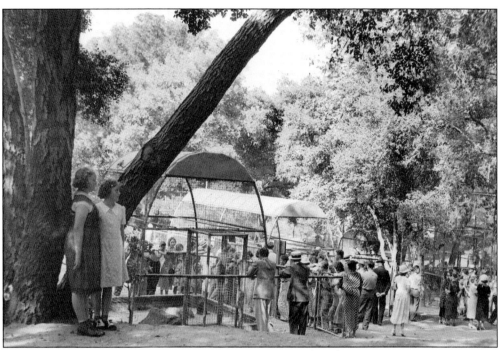

GRIFFITH PARK ZOO, 1938. These two photographs were taken at the Griffith Park Zoo in 1938, the same year that a major flood spilled over the nearby banks of the Los Angeles River, resulting in 115 deaths and the destruction of 5,600 homes. This flood prompted the Army Corps of Engineers to begin a massive project to transform the river from a naturally flowing waterway into a concrete-lined flood channel. It was reported at the time that some zoo animals escaped during these floods. One such story, which may simply be a case of urban legend, claims that AWOL monkeys were later discovered hiding out in the back yard of a Toluca Lake home.

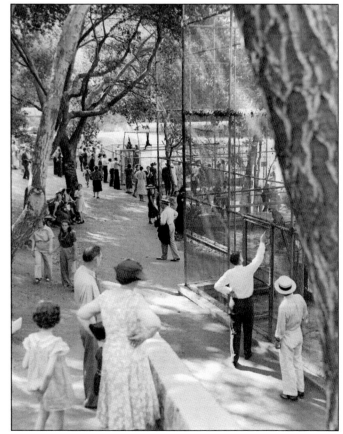

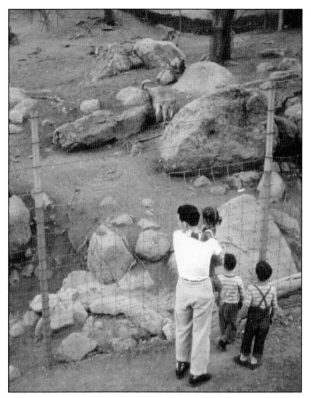

ZOO ANIMALS AND VISITORS, 1950s. In the top photograph, a family peers into a cage, while below, the Griffith Park Zoo elephants extend friendly trunks to the visitors on the other side of the fence. Construction of the zoo's replacement, the Los Angeles Zoo, commenced in the fall of 1964 two miles to the northeast. The Griffith Park Zoo officially ended its 50-plus-year run on August 16, 1966, and the new facility opened nearly four months later. In the interim, all the animals had to be transported to the new facility, which created numerous logistical difficulties. The elephant move was probably the easiest of them all. They simply joined trunks-to-tails in a line and walked to their new enclosure.

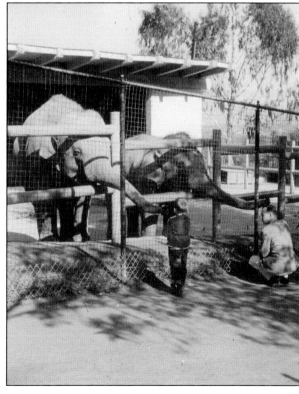

GRIFFITH PARK ZOO, 1950s. A rooster roams with a trio of llamas in this photograph (right) from the 1950s. Below, visitors stand near the small animal cages. There have been numerous reports of animal escapes from both of the park's zoos. The most recent being the 2007 case of an alligator named Reggie from the Los Angeles Zoo. Reggie's story begins in 2005 when he was illegally dumped into a Los Angeles–area lake and eluded capture for two years. After apprehended, he was transferred to the zoo where in August 2007, he went missing and was later discovered near a loading dock. In May 2010, Reggie got a girlfriend when Cajun Kate was moved into his enclosure. Cajun Kate may be more cougar than gator, as she is believed to be about 40 years old, and Reggie is barely out of his teens.

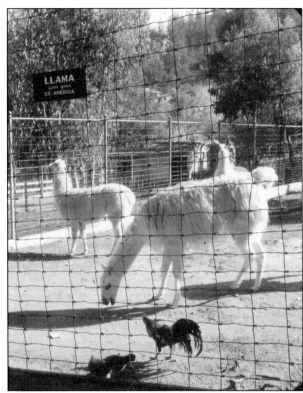

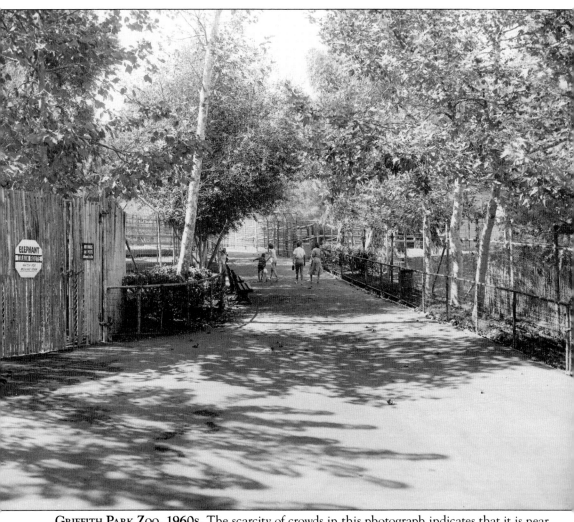

GRIFFITH PARK ZOO, 1960S. The scarcity of crowds in this photograph indicates that it is near closing time. It was nearing permanent closing time for the Griffith Park Zoo when this shot was taken. After the old zoo closed its cages in 1966, the location became a picnic area and a place for concerts in the summer. Hollywood also used the area as backdrops for films, like *Anchorman: The Legend of Ron Burgundy* (2004). Not all the wild animals in Griffith Park are found inside the new Los Angeles Zoo. Signs around the park warn hikers of the dangers of rattlesnakes, and a mountain lion was supposedly seen inside the grounds as recently as 2004. In 1987, coyotes attacked and killed 53 flamingoes inside the zoo, as well as a number of penguins. They struck again seven years later, killing more flamingoes and a rare Andean condor. While usually nocturnal, park rangers report that it is now common to see coyotes in the daytime, after a 2007 brushfire altered their natural feeding habits.

LOS ANGELES ZOO AND THE AUTRY NATIONAL CENTER, 2011. The Los Angeles Zoo (above) and the Autry National Center (below) share land that was once the Griffith Aviation Center and later a California National Guard air station. The Los Angeles Zoo opened on November 28, 1966. In 2010, about 1.6 million people came through the gates to see the 1,100 animals from 250 species housed here. The Autry National Center began as the Autry Museum of Western Heritage on November 22, 1988, when singing cowboy Gene Autry opened the 140,000-square-foot, $54-million facility by cutting a ceremonial rope with a Bowie knife.

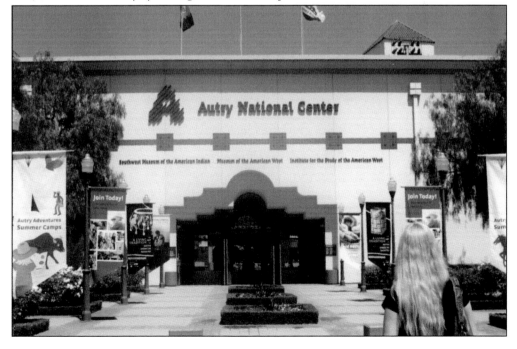

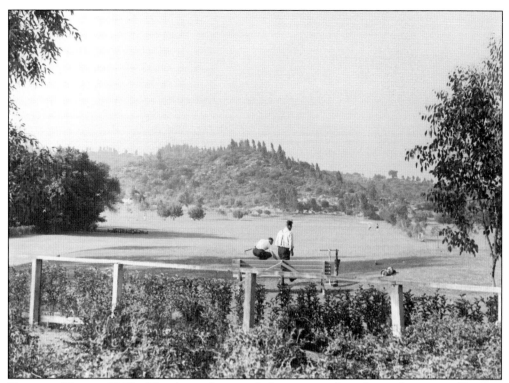

GOLF AND TENNIS, 1940s. The above photograph shows a rare shot of a nearly empty golf course in the 1940s. Golf has been a constant presence inside Griffith Park since the first public course opened in 1900. Today, thousands of rounds of golf are played weekly on the park's five courses. Below, the tennis courts are equally empty in this photograph from the same decade. Tennis is now played in three areas of the park, with one set of courts available free of charge.

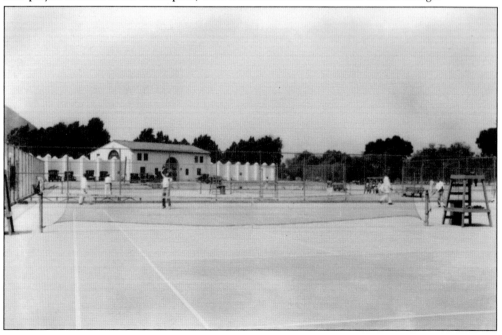

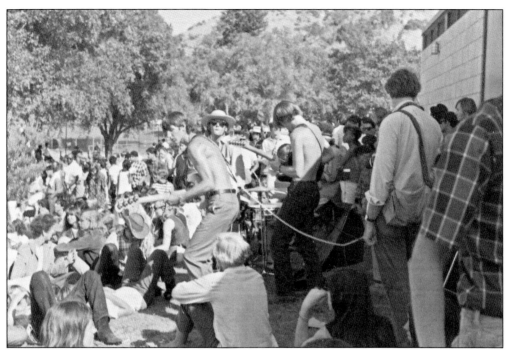

LOVE IN, 1967. The Summer of Love didn't just happen in San Francisco. In 1967, droves of tie-dyed hippies descended on Griffith Park and massed around the park's merry-go-round (above). For nearly every weekend over the next few years, young people met here to experience the counterculture movement in all its varieties. Some simply listened to music and hung out, while others experimented with illegal drugs. The illegal drug part was the biggest no-no for the Los Angeles Police Department (below), who tried to end the mostly peaceful gatherings by making large-scale arrests. In time, the gatherings got more dangerous when a criminal biker-gang element moved in. By the early 1970s, the love-ins were over, but it took several years for attendance at the merry-go-round to reach pre-love-in levels.

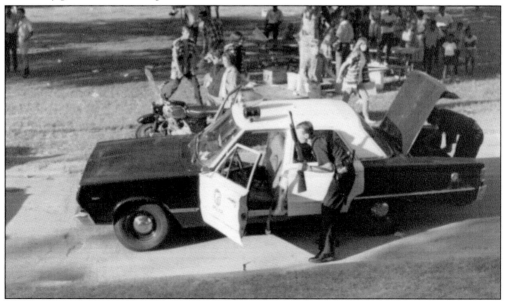

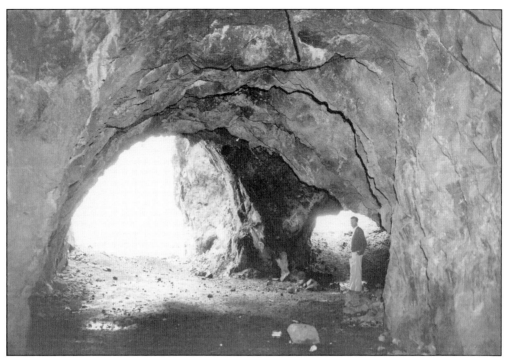

EXPLORING AND RELAXING. These photographs of a man inside Bronson Caves (above) and men sitting in Fern Dell (below) highlight what are undoubtedly the two most popular pastimes in all of Griffith Park: exploring and relaxing. Explorers in Griffith Park can visit anywhere from the outer reaches of the solar system at the Griffith Observatory, to the "condor-minium" at the Los Angeles Zoo. Those wishing to relax can listen to a concert, toss a Frisbee, watch the birds, or follow the example set by the gentleman in Fern Dell by simply . . . relaxing.

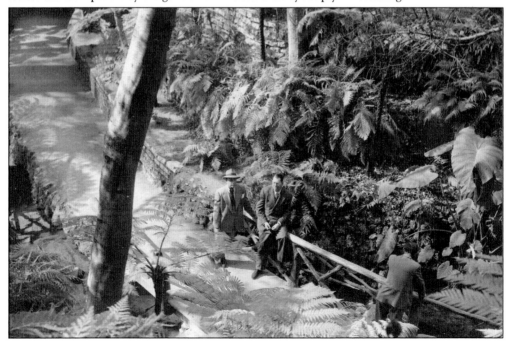

Three

HOLLYWOOD'S BACKLOT

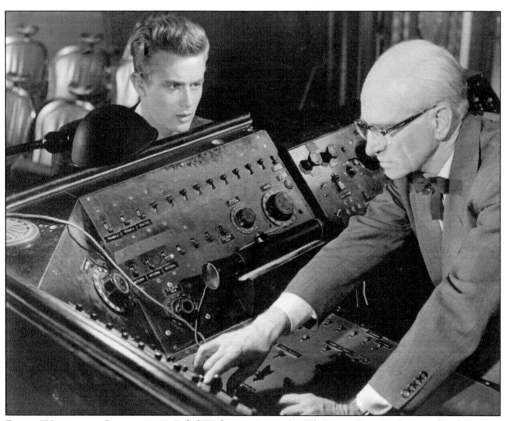

REBEL WITHOUT A CAUSE, 1955. *Rebel Without a Cause* (1955), James Dean's classic tale of teenage angst, had several scenes filmed in and around the Griffith Observatory. Dean is seen here with longtime character actor Ian Wolfe inside the facility's planetarium. Tragically, Dean would die in a car crash just over a month before the film's release.

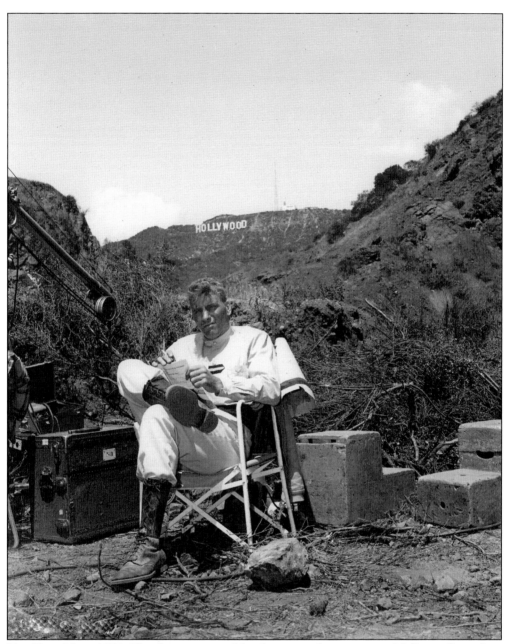

TEN TALL MEN, 1951. Thanks to its varied landscapes and proximity to Hollywood's studios, Griffith Park has been used as a filming site since the earliest days of motion pictures. Films of all genres have been made on the grounds, employing nearly every area inside the seven-square-mile park. In this photograph, Burt Lancaster takes a break from filming *Ten Tall Men* (1951) in Bronson Canyon, in the shadow of the Hollywood Sign. This French Foreign Legion comedy-adventure costarred Jody Lawrance and Gerald Mohr and was produced by Lancaster's production company, Norma Productions, which was named after Lancaster's second wife. Lancaster began his career as part of a circus duo, teamed with his friend Nick Cravat. A hand injury ended the act, and Lancaster turned to acting, becoming one of the most respected thespians of his generation. Cravat would later appear alongside Lancaster in nine films.

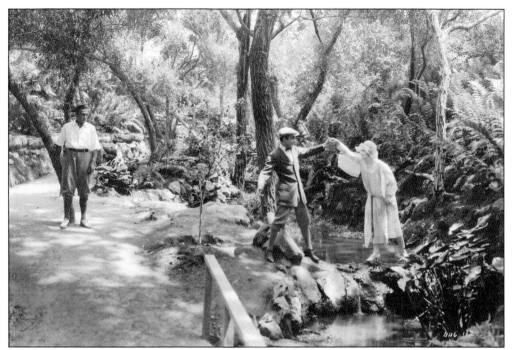

SILENT STARS, 1922. Rudolph Valentino was one of the hundreds of silent film actors to work in Griffith Park. In the above photograph, the 27-year-old Latin lover (left) appears in the park's Fern Dell area in a scene from *The Young Rajah* (1922). Valentino had become an international star and sex symbol in Metro's *The Four Horsemen of the Apocalypse* the previous year. A young actor named William Boyd also appeared in *The Young Rajah*. He would go on to star in 66 films as the legendary Western hero Hopalong Cassidy. Today, many personal items once belonging to Boyd can be found in the park's Autry National Center, including Hoppy's famous black hat. Below, Tom Mix (left) stars in *Catch My Smoke* (1922), one of the hundreds of shoot-'em-ups he made during the 1920s.

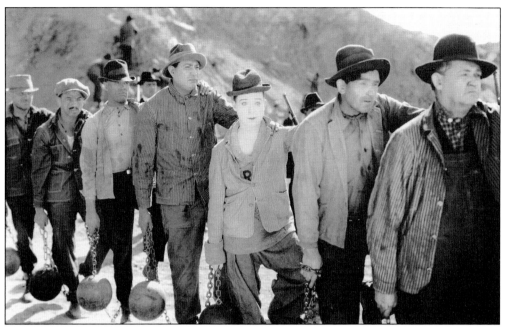

CHAIN GANGS, 1926 AND 1932. Although forgotten today, silent comedian Harry Langdon (above, third from the right) was once considered one of silent film's greatest comics. Here, he is seen in a chain gang in 1926's *Tramp, Tramp, Tramp*. The scene would be repeated in the park six years later—in much more dramatic fashion—in *I Am a Fugitive from a Chain Gang* (1932). This film, which was based on a true story, starred Paul Muni as a man sentenced to a brutal chain gang in the South for a crime he didn't commit. Despite being banned in the state of Georgia, the success of the film provided a much-needed infusion of cash to Warner Bros. and helped bring about reform to the South's penal system. The photograph below was taken in Bronson Canyon.

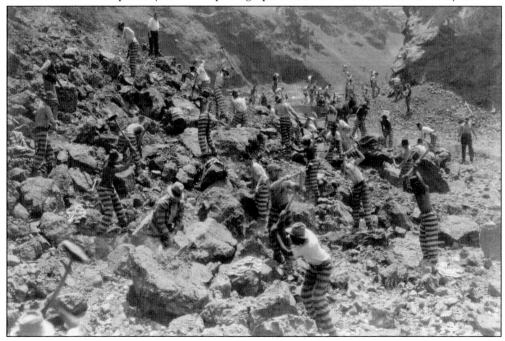

WILLIAM HAINES AND J. WARREN KERRIGAN, 1920S. For a time in the 1920s, William Haines was the top male box office draw. As one of Hollywood's first openly gay stars, Haines's film career ended when MGM released him because of his homosexuality. He would later become a noted interior designer, decorating the homes of many of Hollywood's biggest stars. Haines is seen here in the park's Fern Dell section (above) with an unidentified lady in this undated photograph. Another silent star whose career would suffer because of his homosexuality was cowboy star J. Warren Kerrigan, who made his first film appearance in 1910 as a 30 year old. Kerrigan enjoyed a moderately successful film career for the next 14 years. Below is a still from one of Kerrigan's films, which shows the still-untamed Los Angeles River at the park's northern edge.

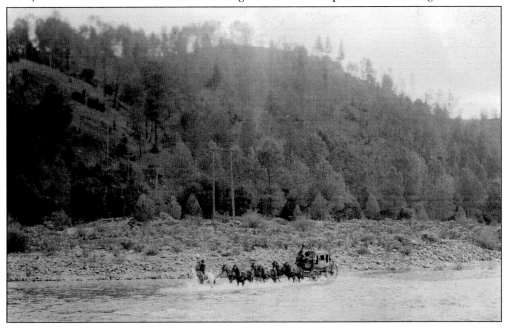

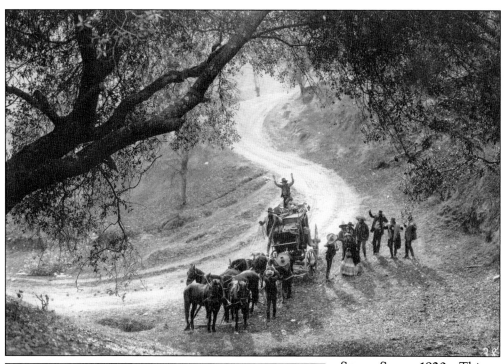

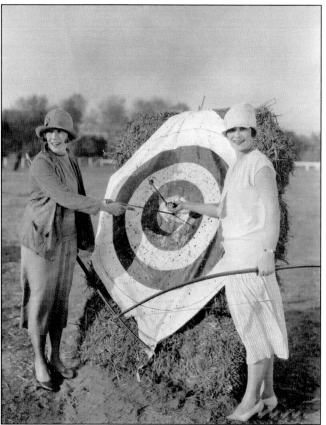

SILENT STARS, 1920s. This stagecoach holdup (above), from an unidentified J. Warren Kerrigan film, takes place on a road in the park's interior. Kerrigan nearly ended his career in 1917, when a reporter asked him if he was planning to serve in World War I. He responded by saying he felt that artists, like himself, should be the last to go after "they . . . take the great mass of men who aren't good for anything else." The "great mass of men" (and women) turned on him, and his popularity never fully recovered. In the photograph to the left, silent film stars Louise Fazenda (left) and Irene Rich pose by a target at an archery range in the park. Fazenda appeared in nearly 300 films during her career and was married for 35 years to producer Hal Wallis.

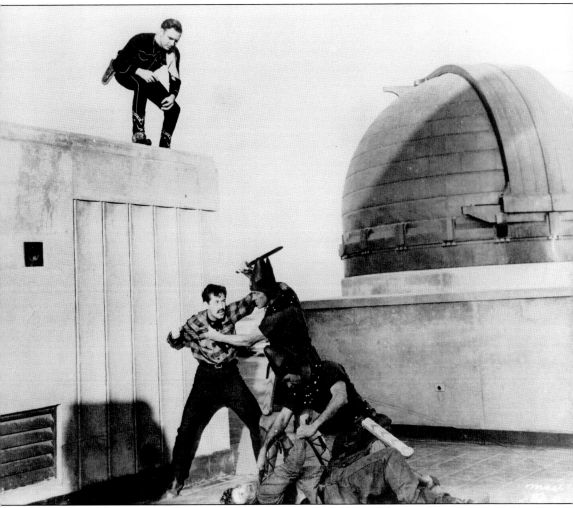

THE PHANTOM EMPIRE, 1935. The Griffith Observatory is one of the top filming sites in the entire park. Gene Autry was one of the first actors to work at the recently completed Art Deco structure. In 1935, he starred here in his first (and easily, most unorthodox) role in the 12-part serial, *The Phantom Empire*. In this singing-cowboy, science-fiction series (no lie), Autry plays a radio cowboy star, who must rescue his two young sidekicks from the clutches of the Mu, an ancient race of humans living miles below his ranch. Autry, seen here on the ledge above the fighters, would make over 90 more films, sell more than 100 million records, and own several radio and television stations, as well as the California Angels (today, the Los Angeles Angels of Anaheim) of Major League Baseball's American League. In 1988, he cofounded what is now called the Autry National Center inside Griffith Park. It is a 140,000-square-foot facility dedicated to preserving the history of the Old West and is located just a few miles from where Autry once battled the Mu at the observatory.

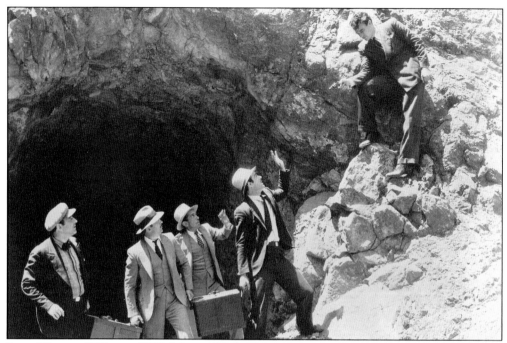

JOHN WAYNE, 1932 AND 1933. Marion "Duke" Morrison grew up across the river from Griffith Park in Glendale and came here several times during his career to star in oaters and occasional non-Western roles. In 1932, Morrison (now known to the world as John Wayne), played a pilot seeking to avenge the murder of his father in a 12-part serial called *The Hurricane Express*. In this scene (above), Wayne holds the bad guys at gunpoint just outside the opening of Bronson Caves. Wayne would return here the following year (below) to film this fight scene from Lone Star's *Sagebrush Trail*, which was released by Monogram Pictures. Several small producers, including Monogram, would merge to become Republic Pictures two years later, and Wayne would become the new company's biggest star.

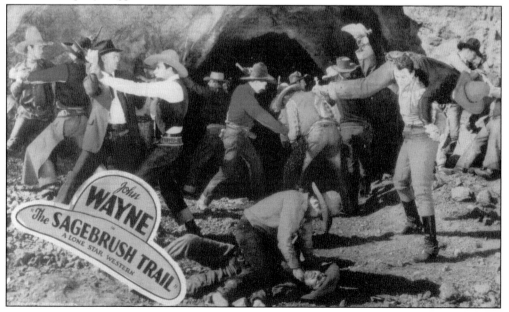

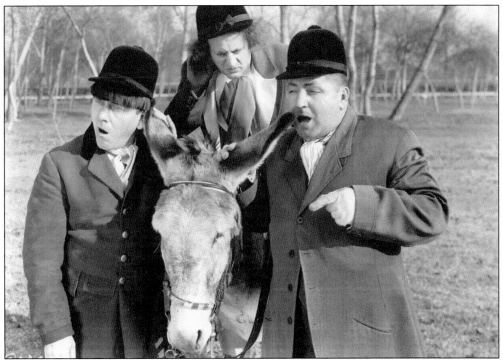

THE THREE STOOGES, 1934 AND 1959. Griffith Park was seen in more than just Westerns and science-fiction films. The Three Stooges brought their face slaps, eye pokes, *nyuk-nyuk-nyuks*, and *woo-woo-woo*s to Griffith Park in the two-reeler *Ants in the Pantry* (1934). In this film, Moe, Larry, and Curly go on an ill-advised foxhunt on a Griffith Park bridle path (above). Twenty-five years later, Moe and Larry were back with "Curly Joe" DeRita in the feature film *Have Rocket Will Travel* (1959). In this scene (below), the Stooges ride through Bronson Canyon on a fire truck (below) with Moe behind the wheel.

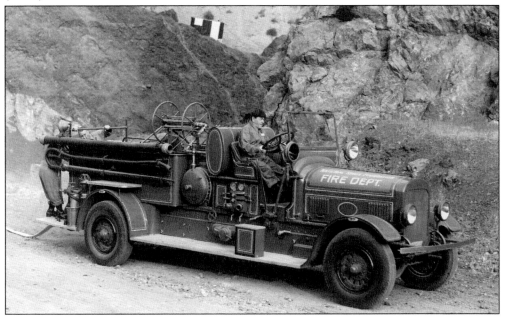

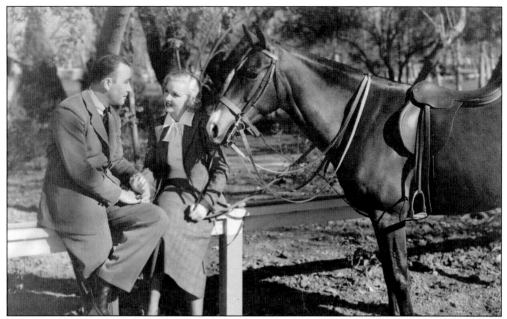

MANHATTAN LOVE SONG, 1934. Hollywood returned to the bridle paths in the comedy *Manhattan Love Song* (1934), starring Dixie Lee and Robert Armstrong. Armstrong starred in *King Kong* the previous year and would end up with 180 screen credits over his 37-year career. Dixie Lee, the first wife of Bing Crosby, would only make two more films before dying in 1952 at the age of 40 from the effects of alcoholism.

SPEED TO BURN, 1938. The same paths would host the crime drama *Speed to Burn* four years later. Equestrian sports continue to be a major activity inside the park, which has more than 50 miles of bridle paths. Pony rides for children are offered in the park's extreme southeast corner, and the park's Equestrian Center is located across the Los Angeles River from the main property, adjacent to the city of Burbank.

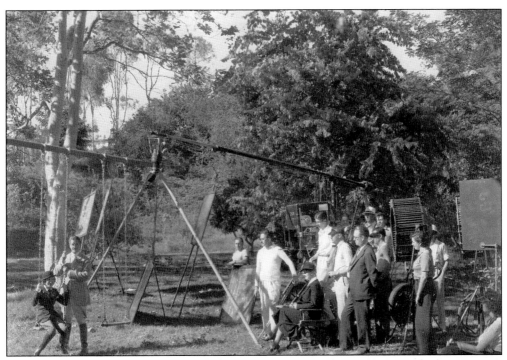

BURNS AND ALLEN AND LORETTA YOUNG. Griffith Park was the setting for this scene (above) from the Burns and Allen comedy *Here Comes Cookie* (1935). Loretta Young (right) strolls through the park's Fern Dell section in this undated photograph. Young won an Academy Award for Best Actress for *The Farmer's Daughter* (1947), the same year she costarred with Cary Grant and David Niven in *The Bishop's Wife*. She later starred in a dramatic anthology series on television, from 1953 to 1961, called *The Loretta Young Show*. Young was married three times and had an affair with Clark Gable, which produced a child.

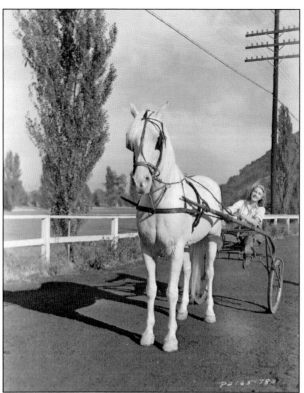

SHIRLEY ROSS, 1939. When mention is made of the film *Some Like It Hot*, it's natural to assume the conversation concerns the classic 1959 Billy Wilder comedy, which starred Marilyn Monroe, Tony Curtis, and Jack Lemmon. But there was another comedy with the same title made 20 years earlier that starred a young Bob Hope and actress Shirley Ross, who is seen here driving her horse Prince through the park.

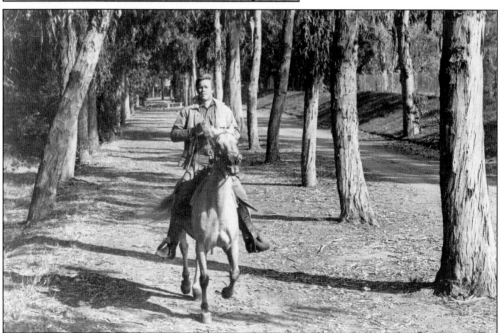

HERVE PRESNELL, 1964. Actor and singer Herve Presnell (above) gallops through the park, 25 years after Shirley Ross rode the bridle paths. Notice the nonnative eucalyptus trees that line the trail. Most were planted by Colonel Griffith in an ill-advised scheme to sell them to railroads for ties (the wood proved unsatisfactory). Eucalyptus trees are now the most common tree in all of Griffith Park.

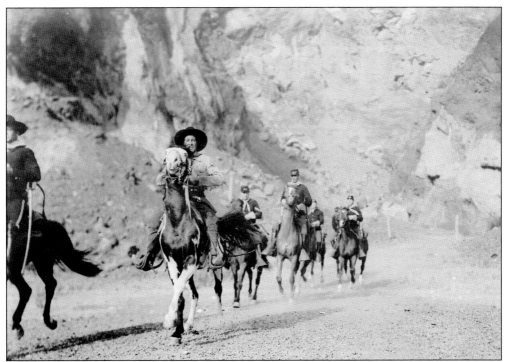

THE GREAT ADVENTURES OF WILD BILL HICKOK, 1938. Wild Bill Elliott (in a black hat, above and below) rides with the US Cavalry through Bronson Canyon in these scenes from 1938's *The Adventures of Wild Bill Hickok*. Elliot would become so associated with the role of Wild Bill in this Monogram serial that he would begin using the nickname for himself in all his later roles. The life of gunfighter (and sometimes lawman) James Butler Hickok—who was gunned down in 1876 in Deadwood, South Dakota—has provided dozens of plots for films and television shows over the years. Hickok would show up again in the early 1950s for eight seasons in the television series *The Adventures of Wild Bill Hickok*, starring Guy Madison. He would come back to life yet again in 2004 during the first season of the extraordinary HBO series *Deadwood*.

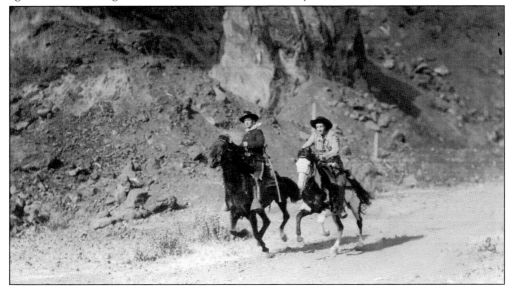

WOLF CALL, 1939. John Carroll was a colorful actor of the 1930s and 1940s. He was born in New Orleans in 1906 and began appearing on screen in the late 1920s. In these two photographs, he appears in the 1939 film *Wolf Call* (above, in white hat), and on a break from the same film (below). In 1942, Carroll would go on to create his most memorable character in *Flying Tigers*, playing a World War II pilot, alongside John Wayne. He would later resurrect the role in real life, when he broke his back in a crash in North Africa. For a time in the 1940s, a struggling young actress named Marilyn Monroe lived with Carroll and his wife. Following his death, Carroll was buried just outside of Griffith Park in the Forest Lawn Hollywood Hills Cemetery.

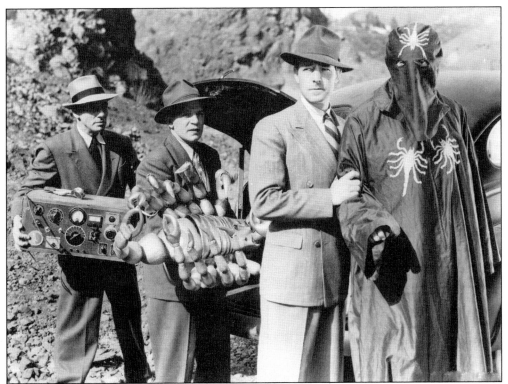

RETURN OF CAPTAIN MARVEL, 1941. Tom Tyler became a star of B-movie Westerns in the 1930s, after striving to develop his acting chops and lose his Lithuanian accent. Although he appeared in such classic productions as 1939's *Stagecoach* and *Gone with the Wind*, he is best known for his portrayal of Captain Marvel in a serial filmed in the 1940s. This scene was shot in Bronson Canyon.

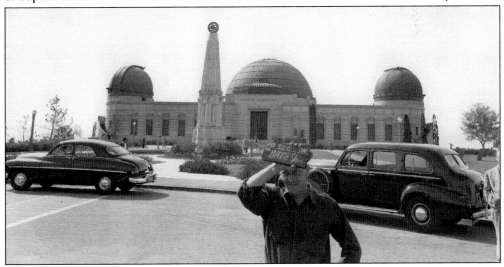

GRIFFITH OBSERVATORY, 1940s. In this photograph, believed to be from the 1940s, a film crew member stands in front of the Griffith Observatory. The words "Matte Shot" on his slate indicate that the background will be altered later with a matte painting. Griffith Observatory rests on the southern slope of Mount Hollywood, and is one of the best places to view the sprawling city of Los Angeles and the Hollywood Sign.

SHIRLEY TEMPLE AND JANE WITHERS, 1940s. Barely out of diapers, child star Shirley Temple helped keep 20th Century Fox solvent during the Depression with a string of hugely successful films. Her career petered out during adolescence, but she did make a few films as a young woman, like the 1947 romantic comedy *The Bachelor and the Bobby-soxer*. In this scene (above), which was shot in the main picnic area by the old zoo, Temple (the bobby-soxer) rides alongside driver (and bachelor) Cary Grant, with Ray Collins, Myrna Loy, and Harry Davenport riding behind. Jane Withers (below) was recruited as one of the wave of "new Shirley Temples" every studio was searching for in the 1930s. Below, she rides a horse in a scene from *A Very Young Lady* (1941) on one of the park's bridle paths.

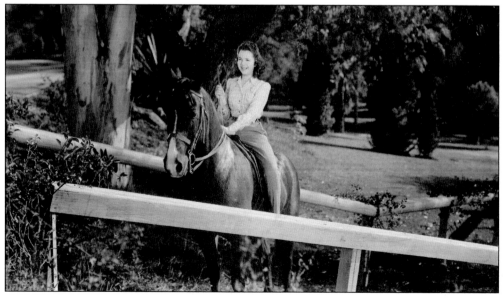

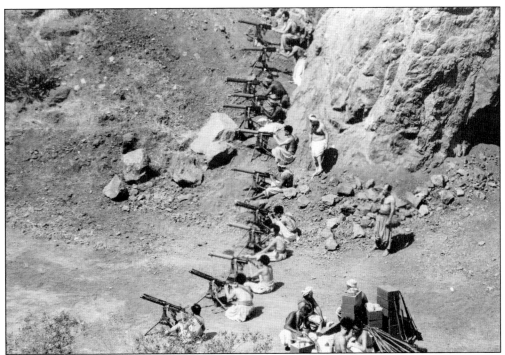

SUNDOWN, 1941. Henry Hathaway came to Bronson Canyon in 1941 to direct the war film *Sundown*, which starred Gene Tierney, Bruce Cabot, George Sanders, and Harry Carey. Hathaway directed dozens of Western stars over a 50-year career, including John Wayne's only Oscar-winning performance in *True Grit* (1969). His dictatorial directing style reportedly cost that film the services of Mia Farrow, who was originally cast in the role of Mattie Ross.

THE LEATHER BURNERS, 1943. This scene, shot in Bronson Canyon, comes from one of the 66 Hopalong Cassidy films William Boyd made between 1935 and 1947. Boyd was a successful silent star who fell on hard times after the arrival of talkies. Envisioning entertainment's future, he later sold everything he owned to buy the rights to the Cassidy films, which he then resold to the new medium of television—reaping fortunes in the process.

THE TIGER WOMAN, 1944. Bronson Caves doubled as a cave in the rainforest of South America in the 12-part Republic serial *The Tiger Woman*, which starred Linda Stirling. It was later rereleased as *Perils of the Darkest Jungle* (1951). Bronson Caves is not a natural formation, but a short, man-made tunnel left over from a rock quarry that operated in the canyon from 1903 to the late 1920s.

THE ADVENTURES OF MARK TWAIN, 1944. Griffith Park's neighbor Warner Bros. came to Bronson Canyon to film *The Adventures of Mark Twain* in 1944. The film was produced by Hollywood pioneer Jesse Lasky, who once owned a film ranch on land located between the park's western edge and the Warner lot. Lasky's ranch was where *The Birth of a Nation* (1915) was filmed. Today, two cemeteries occupy the site.

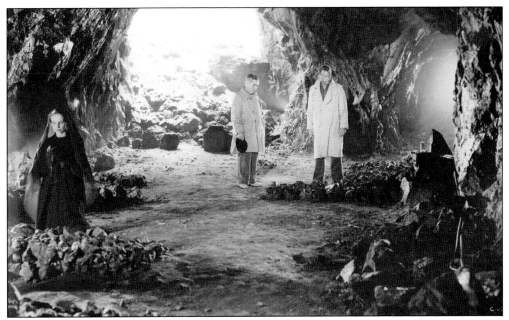

CORNERED, 1945. Dick Powell (far right) began his career as a singer in the 1920s and made it to Hollywood after Warner Bros. purchased Brunswick Records, which had him under contract. For his first decade on screen, the boyish Powell was usually cast in nice-guy roles. In the 1940s, Powell starred in a series of film noir pictures, like the taut, post–World War II thriller *Cornered*. This scene from the movie was filmed inside Bronson Caves.

SPLIT SECOND, 1952. Powell came back to Bronson Canyon to make his directorial debut in *Split Second* (1952) seven years later. The story follows escaped convicts who take hostages and hole up in a desert ghost town, unaware that the government has scheduled an atomic test nearby. From left to right are Keith Andres, Jan Sterling, Stephen McNally, and Arthur Hunnicutt.

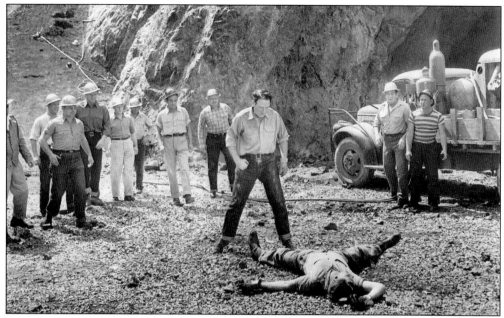

DYNAMITE, 1949. In 1949, Paramount Pictures came to the same canyon to film *Dynamite*, starring William Gargan. Gargan was born in Brooklyn in 1905 and, for a time, sold bootleg liquor with his partner Dave Chasen, who would later open the swank Beverly Hills eatery that bore his name. Gargan enjoyed a long career in film and television before dying of a heart attack in 1979 while on an airline flight.

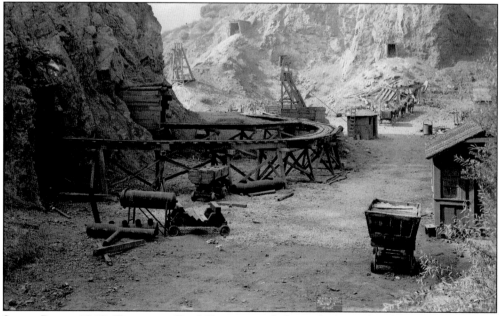

SILVER RIVER, 1948. Tasmanian Errol Flynn starred alongside Ann Sheridan in *Silver River* in 1948, which turned Bronson Canyon into a silver mine. Flynn stormed out of the gate in the Warner Bros. production *Captain Blood* (1935), becoming a sensation with the fans (if not with Jack Warner, who would spar with him for years). Sheridan came to Hollywood after winning a screen role as a prize in a beauty contest.

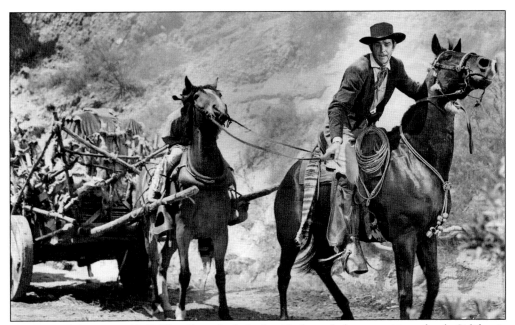

PIRATES OF MONTEREY, 1947. This film, which deals with the turbulent transition of early California from Spanish to Mexican rule, also used Bronson Canyon. This was a case of art imitating real life, as the Feliz family—who originally owned the rancho that later became Griffith Park—were staunch supporters of the Spanish crown, and began losing their hold on the property with the change in government to Mexican rule in 1821.

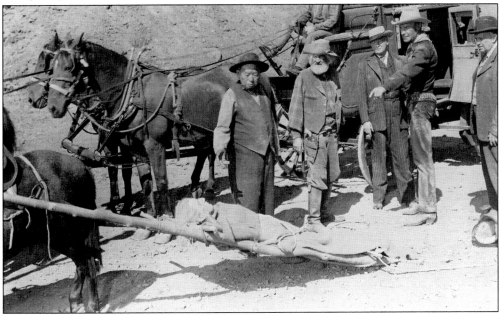

THE CARIBOO TRAIL, 1950. George "Gabby" Hayes (bearded) made his last film appearance in *The Cariboo Trail*, supporting Randolph Scott (pointing). Hayes, possibly the best-loved Western sidekick of them all, became "Gabby" after leaving the Hopalong Cassidy series, where he was known as "Windy." Scott was a top box-office draw for years and was worth an estimated $100 million at the time of his death.

Joe Palooka Meets Humphrey, **1950.** Joe Palooka was a popular comic-strip character, created by Ham Fisher in 1921. Palooka was a good-natured heavyweight boxer, who didn't like to fight, preferring instead to defend the little guy. A popular figure on radio, film, and later television, the character of Palooka was featured in 11 low-budget films in the late 1940s and early 1950s, including *Joe Palooka Meets Humphrey*, which was partly filmed in the park.

Space Patrol, **1950s.** Even though 3-D television may be the latest technological craze, it's got nothing on the 1950s science-fiction show *Space Patrol*, which had a 3-D episode broadcast way back in April 1953. The show was based around the 30th-century adventures of Commander Buzz Corry and Cadet Happy, played by Ed Kemmer and Lyn Osborn. Here, the stars pose in front of a "20th-century" vehicle outside of the observatory.

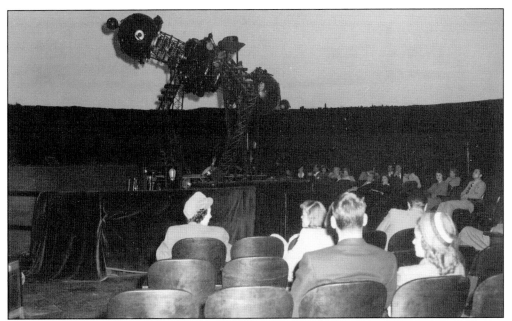

DARK CITY, 1950. Charlton Heston made his Hollywood debut in *Dark City* in 1950, playing a grifter. The film also featured Jack Webb and Harry Morgan, who would later team up as Los Angeles police officers in *Dragnet*. This scene, from inside the observatory's planetarium, features the original Zeiss planetarium projector. Looking like "a thing from another world," the projector was a beloved prop for 1950s science-fiction filmmakers.

FLAME OF ARABY, 1951. Bronson Canyon became the Middle East in this film, featuring Jeff Chandler (seen here) and Maureen O'Hara. Chandler was a Jewish boy from New York named Ira Grossel, whose was six feet four inches tall and white-haired while still in his teens. He died prematurely at age 42 from blood poisoning after undergoing back surgery.

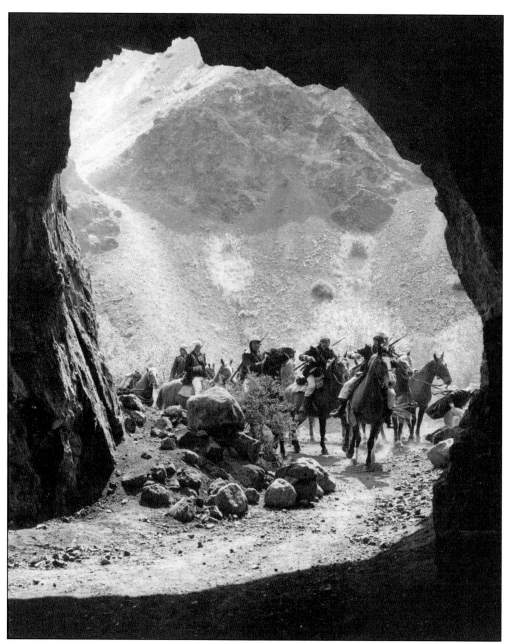

TEN TALL MEN, 1951. This photograph was taken in 1951 from inside Bronson Caves looking out at mounted French Foreign Legion soldiers in *Ten Tall Men*. Burt Lancaster was in the fifth year of his career at the time he starred in this film. A self-trained actor, Lancaster was for many years a major box office star and producer. He wanted to be known as a serious actor—rather than simply a movie star—and began choosing riskier roles. This decision lessened his popularity but helped seal his legacy as one of the most respected actors of his generation. Bronson Caves has been a popular filming site since the earliest days of movies, especially in Westerns and science-fiction stories. *Batman's* Adam West (or at least a stunt driver) saw this same view when driving the Batmobile out of the Batcave in the campy 1960s television series.

BURT LANCASTER, 1951. Lancaster's irritability can almost be felt on the set of *Ten Tall Men* (above and below). Lancaster was often grumpy during filming, yet was somehow still loved by the crews. Lancaster's crankiness carried over to his family life, where his son Bill modeled the character of the cantankerous little league coach in his screenplay for *The Bad News Bears* (1976) after his father. Politically liberal, Lancaster participated in Martin Luther King Jr.'s March on Washington in 1963. Because of his anti–Vietnam War stance, he turned down the lead role in *Patton* (1970), which went to George C. Scott. He lost the role of Don Corleone in *The Godfather* to Marlon Brando two years later. Ironically, both Scott and Brando won Oscars for their performances—and refused to accept them.

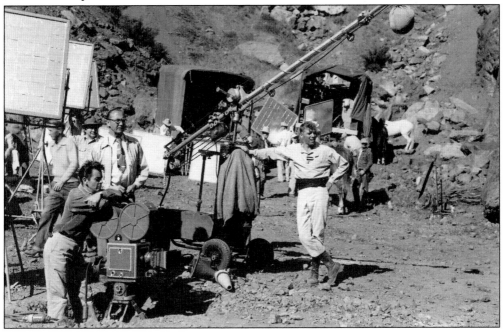

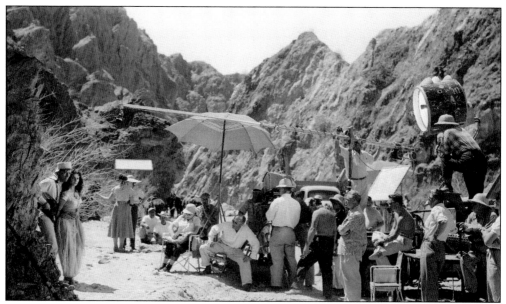

BRONSON CANYON, 1951 AND 1935. This scene (above) from *Ten Tall Men* (1951) shows Burt Lancaster and Jody Lawrance (far left) with a film crew in Bronson Canyon. Lawrance, born Nona Josephine Goddard in 1930, was for a time the foster sister of Marilyn Monroe. She was on her way to stardom when she made this film, but was cut from her contract the following year. In 1953, she was working as a waitress when she served her former costar Lancaster. He promised to get her back into Hollywood and made good on his word. After resuming her career, she continued acting until 1962. The photograph below is from the 1935 film *The Last Days of Pompeii*, with Preston Foster (left) and Alan Hale, which was also shot in Bronson Canyon.

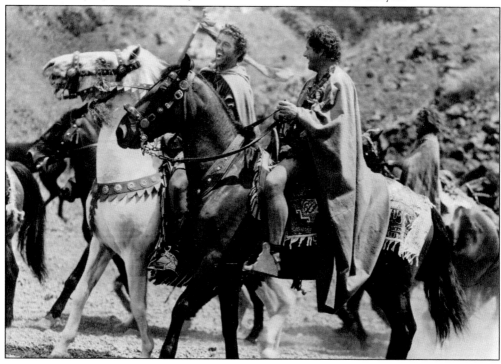

JULIUS CAESAR, 1953. Roman legions storm through Bronson Canyon in this photograph from MGM's 1953 production of *Julius Caesar*. Marlon Brando (astride the horse, right photograph) was cast in the role of Marc Antony, which elicited smirks from many who felt he was unsuited for the role. Despite this, Brando's performance earned him his third straight nomination for Best Actor. He would win the coveted Oscar the following year for *On the Waterfront* (1954). Overall, *Julius Caesar* received five nominations, including Best Picture. The film was produced by John Houseman and directed by Joseph L. Mankiewicz. Houseman had previously worked with Herman Mankiewicz— Joseph's elder brother—on Orson Welles's classic drama *Citizen Kane* (1941).

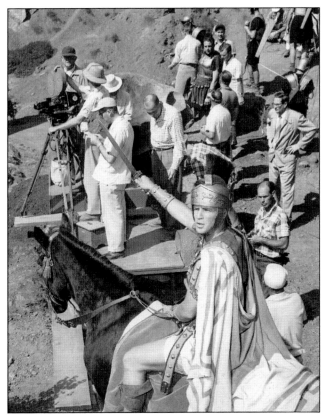

WAR FILMS, 1953. One canyon, two wars. Arrows rain down on centurions in this scene from 1953's *Julius Caesar* (above). During the same year, Bronson Canyon was the stage for *Rogue's March*, another war film (left), set nearly 2,000 years later during the British colonial era in India. The photograph below shows soldiers being filmed near the canyon walls, with studio trucks and crew members off camera. Notice the poster for *Quo Vadis* on the truck. This was another Roman Empire drama released two years earlier, which was rare in that it was not filmed in Bronson Canyon. This steep, rocky canyon has served as a backdrop for countless cinematic conflicts over the past century, most often in Westerns. But as these photographs prove, it can just as easily double for the Roman Empire or the Kyber Pass.

ROGUE'S MARCH, 1953. Peter Lawford came to Bronson Canyon to star in this war film, set in British India. Born in London, but raised in France and America, Lawford was kept out of serving in World War II because of an arm injury he sustained as a boy. This proved fortunate for his career, as he was soon playing parts that probably would have been filled by bigger stars, had they not been off to war. He was, for a time, married to Pres. John F. Kennedy's sister and later to Dan Rowan's daughter Mary, who he met on her father's television show, *Laugh In*. Lawford was a member of the Rat Pack—a womanizing, boozing bunch of performers that consisted of Frank Sinatra, Dean Martin, Sammy Davis Jr., and Joey Bishop. As the brother-in-law to the president (Sinatra nicknamed him "brother-in-Lawford"), Lawford was kicked out of the group when he was blamed for a snub by JFK, who once chose to stay at Bing Crosby's estate, rather than at Sinatra's.

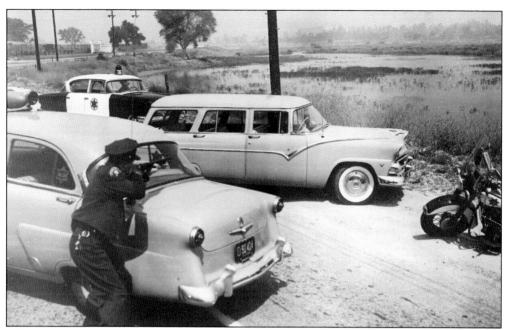

BOBBY WARE IS MISSING, 1955. The crime drama *Bobby Ware is Missing* begins when two boys fall down a ravine and get trapped on a ledge. A would-be extortionist learns the boys are missing, pretends to be a kidnapper, and demands a $10,000 ransom for their return. This scene (above) was shot on Zoo Drive within the park, looking west. On the horizon is the water tower for the Walt Disney Studios in Burbank. In the photograph below, the boys exit a helicopter in Bronson Canyon after being rescued. Craggy-faced Neville Brand stars as police lieutenant Andy Flynn in the film. Brand was one of the most decorated American soldiers to serve in World War II.

DEVIL GODDESS, 1955. These two stills are from the jungle movie *Devil Goddess* from 1955. In the above photograph, star Johnny Weissmuller (top, right) leafs through the script, while two actors look on. Weissmuller was the Michael Phelps of his day, tearing through world swimming records by the dozen. Famous for his Tarzan roles, Weissmuller never actually said "Me Tarzan, you Jane" in any of his films. He jokingly uttered the line in a studio parking lot when he rushed to the aid of costar Maureen O'Sullivan as she struggled to lift a heavy suitcase into the trunk of her car. Several people were standing nearby. The line made it into the stories told the next day on set and eventually into the cultural lexicon.

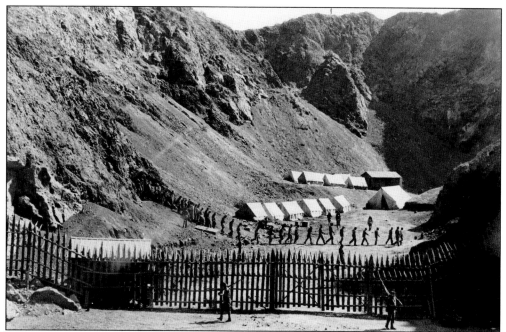

***HELLGATE*, 1952.** Sterling Hayden starred in this 1952 Western about a harsh New Mexico prison. On at least two occasions, Griffith Park has been the site of real-life prisons. From 1918 to 1924, the park's northern end housed a 160-acre minimum security prison farm. During World War II, the area now known as Travel Town was the site of a POW camp.

***THUNDER PASS*, 1954.** Bronson Canyon models as the treacherous Thunder Pass in this hackneyed, white-man-speak-with-forked-tongue-dialogued B-Western. Dane Clark, upper left, stars as the Army captain who attempts to save a group of settlers from a warring confederation of Comanche and Kiowa Indians. A nearly unrecognizable Raymond Burr (standing, center) plays one of the settlers. He would become a television star in *Perry Mason* three years later.

GRIFFITH OBSERVATORY, 1955. In 1912, Colonel Griffith followed up on his initial 1896 gift to the city with an offer of $100,000 to construct an observatory atop Mount Hollywood. When the Colonel's original gift of the land was made, he was seen as a generous—albeit pompous—benefactor. When he offered the second gift, he was a convicted attempted murderer, and it was promptly rejected. The observatory was later built after Griffith's death from funds left in his will, at a site lower on the mountain than the Colonel had intended. From nearly the day it opened in 1935, Hollywood filmmakers have used the Art Deco structure as a set. In these nearly identical scenes from 1955, Tommy Clark (right) races through a curved exterior walkway in *Teen-Age Crime Wave*, as does Sal Mineo (below) in *Rebel Without a Cause.*

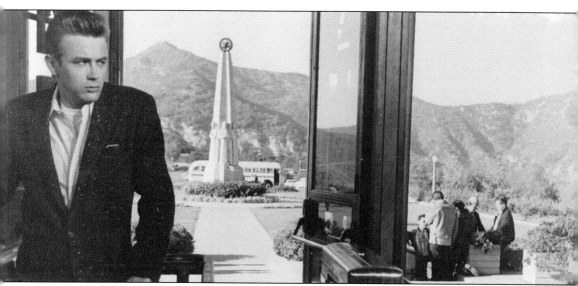

REBEL WITHOUT A CAUSE, 1955. The most famous film ever shot inside Griffith Park is undoubtedly *Rebel Without a Cause* (1955). Seen here is the film's star, James Dean, who stands inside the observatory's front entrance with the Astronomer's Monument visible behind. The Astronomer's Monument is a government-funded, 40-foot memorial to six legendary figures in astronomy. George Stanley, who created the famous Oscar statuette for the Academy Awards, was one of the sculptors. Dean would be nominated for two Oscars (in only three roles) during his brief career. He would never see the finished version of *Rebel*, because he died in a car crash in Central California just weeks before its release. Today, a statue of Dean stands just a few hundred feet to the north of the Astronomer's Monument, at the site of the film's knife fight (see page 15).

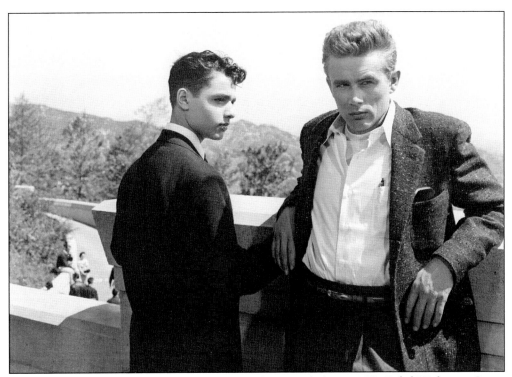

REBEL WITHOUT A CAUSE, 1955. The above photograph from 1955's *Rebel Without a Cause* features Sal Mineo (left) and James Dean on the grounds of the Griffith Observatory. Below, Dean stands inside the observatory foyer. In 2002, the observatory closed for four years for a $93-million renovation, which added thousands of square feet of new underground exhibition space. Today, the observatory features a Wolfgang Puck restaurant called the Café at the End of the Universe—an obvious homage to science-fiction comic Douglas Adams. The observatory is still a frequent backdrop for films, appearing in recent years in the original *Transformers* (2007), *Yes Man* (2008), and *Terminator Salvation* (2009). It shows up regularly on television, even appearing in an episode of the animated comedy *The Simpsons.*

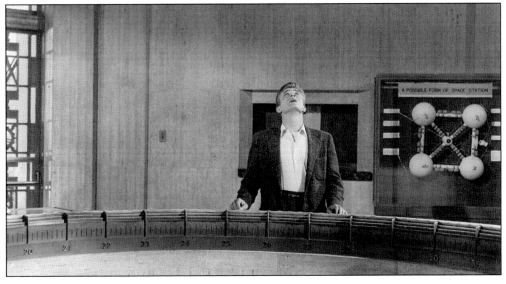

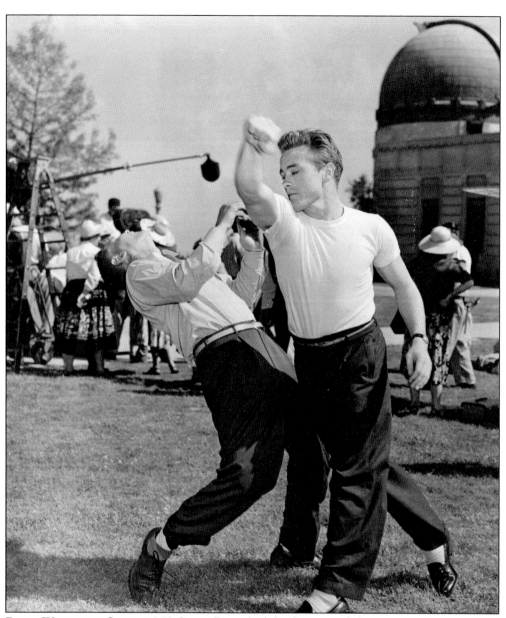

REBEL WITHOUT A CAUSE, 1955. James Dean (right) rehearses a fight scene on the grounds of the Griffith Observatory. Jim Backus, who plays Dean's henpecked father in the film, would later become famous for two television roles in the 1960s: the voice of the myopic animated character *Mister Magoo* (1960–1961) and as millionaire Thurston Howell III in *Gilligan's Island* (1964–1967). Backus was something of a "rebel" himself as a youth, having been expelled from the Kentucky Military Institute for riding a horse through the mess hall. All three stars of the film—Dean, Sal Mineo, and Natalie Wood—would die at an early age (Were they victims of the Petranilla Curse [see page 15]?). James perished in a Central California car crash on September 30, 1955, just weeks before the release of the film; Mineo was stabbed to death in a 1976 robbery; and Natalie Wood drowned in 1981. The entire cast has now passed away. Corey Allen, who played James Dean's nemesis Buzz in the film, was the last member of the cast to die, passing just two days shy of his 76th birthday in June 2010.

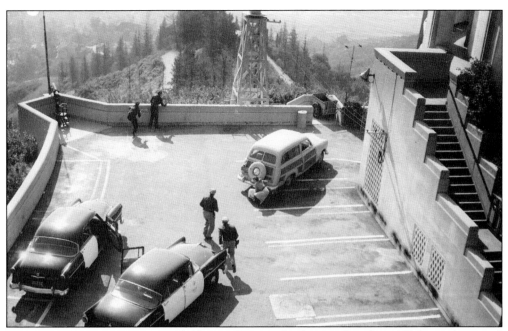

TEEN-AGE CRIME WAVE, 1955. Child actor Tommy Cook starred in this 1955 "teen-ploitation" film. Born in Minnesota, Cook began acting after his family moved to California when he was a child. Because of his dark complexion, he was often cast in exotic roles, like in *The Adventures of Red Ryder* (1940), where he played a Native American boy. In the photograph above, police pursue Cook through the Griffith Observatory's parking lot. In the film's climactic fight scene (below), Cook and Frank Griffin brawl inside one of the observatory's copper-coated domes. Originally, the plans called for the covering of the domes to be ceramic tile, but copper was later substituted. The metal was replaced during the extensive $93-million renovation that took place at the observatory between 2004 and 2008.

BADLANDS OF MONTANA, 1957. The Western *Badlands of Montana* is a story about a man (Rex Reason) who is forced to become an outlaw after he kills a rival in a fair fight. Much of the 1957 film was shot at Chatsworth's Iverson Ranch, but these two scenes were filmed in Bronson Canyon. In the above photograph, the film's star, Reason (left), rides alongside Emile Meyer. In the scene below, outlaw Rick Valentine, played by Keith Larsen, robs a stagecoach. Rex Reason began his film career in 1952 and later starred in the 1960s television series *The Roaring 20s*. Frank Sinatra reportedly wanted Reason for the part that eventually went to Laurence Harvey in *The Manchurian Candidate*. Sinatra eventually passed on Reason after several unsuccessful attempts to reach him by phone.

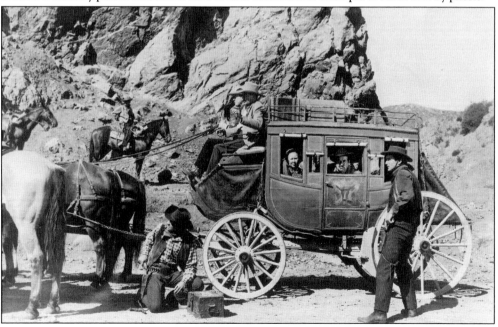

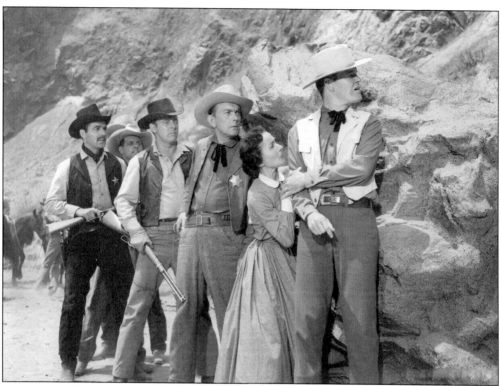

RETURN TO WARBOW, 1958. The Columbia production *Return to Warbow* is the story of Clay Hollister (Philip Carey), an escaped convict who returns to the town of Warbow with two accomplices to recover $30,000 he stole 11 years earlier. The trio takes an 11-year-old boy hostage (Christopher Olsen), who turns out to be Hollister's son. In these photographs, a posse tracks the criminals to Bronson Caves, which has been fashioned into an abandoned mine. Above, from left to right, are Paul Picemi, an unidentified man, Harry Lauter, Francis De Sales, Catherine McLeod, and Andrew Duggan. In the photograph below, the posse rides through Bronson Canyon.

INVASION OF THE BODY SNATCHERS, 1956. Another classic film of the 1950s—this time from the science-fiction genre—was shot in Griffith Park. Dana Wynter (left) and Kevin McCarthy hide out in Bronson Canyon while invading alien pod people take over the bodies of humans as they sleep. The main setting for the film was the Los Angeles suburb of Sierra Madre, but it also used settings in and near Griffith Park. The film was seen by some as a warning against encroaching communism and by others as an indictment of McCarthyism. The film was made for under $400,000 and took in two-and-a-half times that amount during its first month of release. In 2008, *Invasion of the Body Snatchers* made the American Film Institute's top-10 list of all-time-best science-fiction films. It was remade with Donald Sutherland under the same title in 1978 and again in 2007 as *The Invasion*, with Nicole Kidman and Daniel Craig.

SOMETHING OF VALUE, 1957. Dana Wynter (see page 110) returned to Griffith Park the following year to costar with Rock Hudson and Sidney Poitier (seen here) in the East African colonial drama *Something of Value*, a story based on the Mau Mau Uprising in Kenya. In the film, Hudson and Poitier play two boyhood friends who later end up on opposite sides of the racial conflict that tears their nation apart. Bahamian Poitier had his breakout performance two years earlier in *Blackboard Jungle* and would earn his first Academy Award nomination in 1958 for *The Defiant Ones*. He became the first African American man to win the Oscar for Best Actor for *Lilies of the Field* five years later. Over the next several years, he would star in, and occasionally direct, several more successful films and would serve as a Bahamian diplomat. In 2009, Poitier was awarded the Presidential Medal of Freedom by Pres. Barack Obama. Ironically, the president's father was born in Kenya and came to America in 1959 on a scholarship that was partly funded by Sidney Poitier.

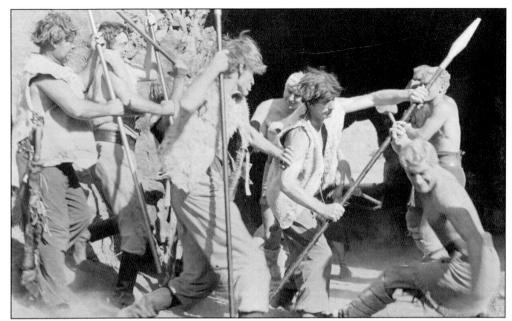

VIKING WOMEN AND THE SEA SERPENT, 1957. The complete title of the 1957 film *Viking Women and the Sea Serpent* is *The Saga of the Viking Women and Their Voyage to the Waters of the Great Sea Serpent* (which pretty much spells out the plot). It was directed by low-budget film master Roger Corman, who helped launch the careers of several of Hollywood's biggest stars, including Jack Nicholson and Robert De Niro.

EARTH VS. THE SPIDER, 1958. Bert I. Gordon, one of the directors who worked with Roger Corman in the 1950s, was known as "Mr. Big"—both for his initials and for his theremin-themed thrillers about giant monsters, like 1957's *The Cyclops* (see page 113) and the eight-legger seen in *Earth vs. the Spider* (1958). Above, the film's star, Ed Kemmer, stands outside of Bronson Caves, the giant spider's lair.

THE CYCLOPS, 1957. In 1957, Bronson Caves became the home of the one-eyed beast in *The Cyclops*. This story is about a woman who searches for her lost husband in Mexico, where radiation contamination has mutated the local creatures—including her husband—into giant, hideous monsters ("The spawn of nuclear fury!"). Posing on a boulder at the cave's entrance (above) are, from left to right, an unidentified man, Gloria Talbott, Tom Drake, and James Craig. Talbott, Drake, and Craig move through the canyon in the photograph below. Duncan Parkin, the 25-foot mutated man, played essentially the same role in *War of the Colossal Beast* (1958), another Bert I. Gordon offering. At the climax of that film, the beast terrifies a group of children inside a school bus who are on a field trip to Griffith Observatory.

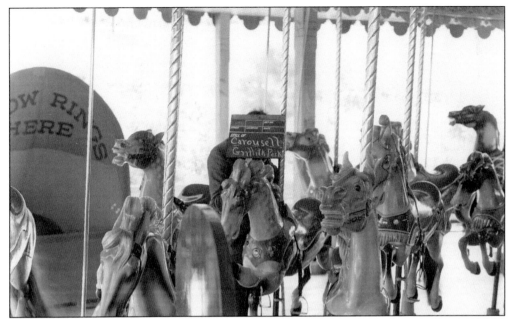

GRIFFITH PARK MERRY-GO-ROUND. The Griffith Park Merry-Go-Round was built in 1926 by Spillman Engineering for San Diego's Mission Beach and saw use for two years at the San Diego Expo before moving to Griffith Park. It has been in its current location since 1937. In this undated photograph, some of the 68 hand-carved jumpers on the "Carousell" [*sic*] are being photographed in preparation for an upcoming production.

SON OF SINBAD, 1955. Vincent Price (center), Dale Robertson (right), and two unidentified women create the mysterious "Greek fire" in Bronson Canyon to fight the forces of the invading Tamerlane. Yale-educated Price was nearly two decades into his film career at the time of this low-budget Howard Hughes production. He had starred in *House of Wax* two years earlier and would see his greatest film success during the 1960s.

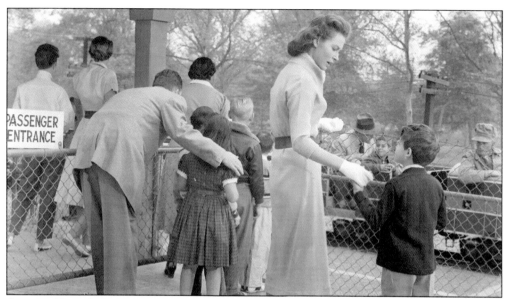

GRIFFITH PARK & SOUTHERN RAILROAD, 1957 AND 1979. In the above photograph, Italian beauty Gia Scala takes young Eugene Mazzola for a ride at Griffith Park's miniature railway, the Griffith Park & Southern Railroad, in *Four Girls in Town* (1957). The film follows four women who come to Hollywood to try out for a part and the four men who pursue them. Sydney Chaplin plays one of the pursuers. His father, the legendary silent comic Charlie Chaplin, filmed in Griffith Park during the 1910s. In 1979, engineer Steve Martin (below) takes a trainload of children for a ride along the same track in the comedian's debut film, *The Jerk*. The Griffith Park & Southern Railroad first opened just after the conclusion of World War II, near the park's Riverside Drive entrance.

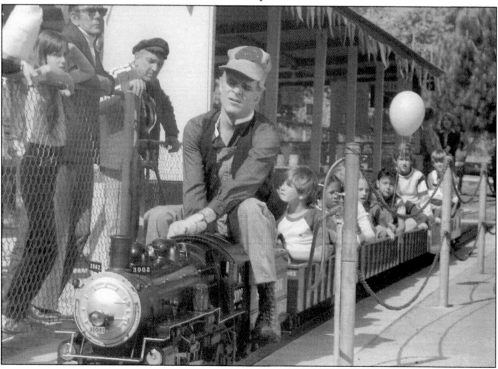

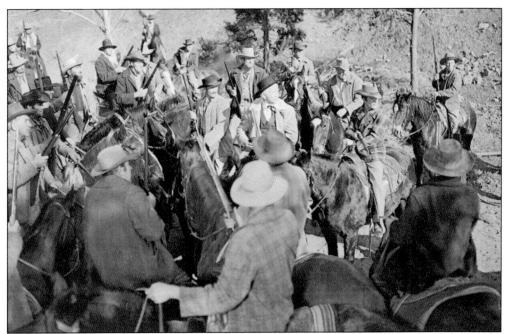

GUN GLORY, 1957. Chill Wills (black hat, center) plays a "gun-toting frontier parson" at the head of a posse in Bronson Canyon in this story of redemption, starring English-born Stewart Granger. Wills had a 44-year career that featured several memorable roles in major Western productions, like *Giant* (1955). In 1960, he was nominated for Best Supporting Actor for his role in *The Alamo* (1960).

MEN IN WAR, 1957. The outstanding Korean War drama *Men in War* follows a platoon of American soldiers through the course of one day—September 6, 1950. In this scene, Korean soldiers fight in Bronson Canyon. The story was based on the 1949 war novel *Combat* (originally *Day Without End*). Coincidentally, Vic Morrow, who plays one of the soldiers, would later star in *Combat!*, a World War II television drama.

MEN IN WAR, 1957. In *Men in War*, Robert Ryan stars as a Korean War lieutenant trying to lead his platoon back to safety from behind enemy lines. Because the Pentagon objected to the script, the Army provided no military extras or vehicles for the film. The filmmakers compensated by making the stark, rugged landscape of Bronson Canyon the star, rarely showing the enemy up close. Above are, from left to right, Aldo Ray, Robert Ryan, and Phillip Pine. In the photograph below, the soldiers take sanctuary inside Bronson Caves. Actor Robert Keith, who had a long Hollywood career, plays a shell-shocked colonel in the film. He was the father of actor Brian Keith and was briefly married to actress Peg Entwistle in the 1920s. In 1932, Entwistle committed suicide by leaping from the Hollywood Sign, which is visible from Bronson Canyon.

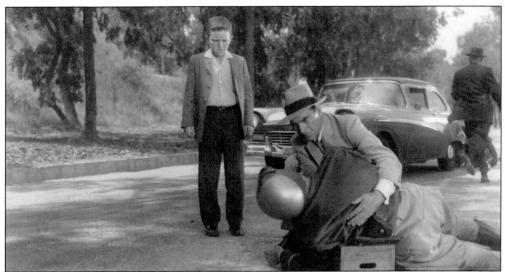

JOHNNY ROCCO, 1958. Richard Eyer (left) and Stephen McNally appear in this scene from *Johnny Rocco*, shot on Zoo Drive. A year earlier, child actor Eyer starred alongside Robby the Robot in *The Invisible Boy*, which was a sequel to *Forbidden Planet* (1956). As a boy, Eyer appeared in several films and more than 100 episodes of television. He retired from Hollywood at age 21 and later became an elementary schoolteacher.

TANK BATTALION, 1958. Another low-budget offering from American International Pictures (AIP)—the home of Roger Corman and Bert I. Gordon—was *Tank Battalion* (1958). Bronson Canyon was a frequent filming location employed by AIP because of its proximity to Hollywood and the ease with which it could be modified for use in science-fiction, Westerns, and war films.

THE DIARY OF A HIGH SCHOOL BRIDE, 1959. The Park's Zoo Drive, just north of the Los Angeles Zoo, is the site of this scene from the "teen-ploitation" flicker *The Diary of a High School Bride* (1959), another AIP film from the 1950s. It was standard procedure for AIP filmmakers to come up with a title, create a shocking, eye-catching poster—and only then to write the movie!

HOT CAR GIRL, 1958. Juvenile delinquent Richard Bakalyan tries to elude police after being forced out of his Bronson Caves hiding place by tear gas in 1958's *Hot Car Girl*. Bakalyan starred in a string of teenage crime dramas. He and fellow actor Dickie Jones were once arrested while filming a juvenile delinquent film, when police officers thought they were real criminals and not just playing them on screen.

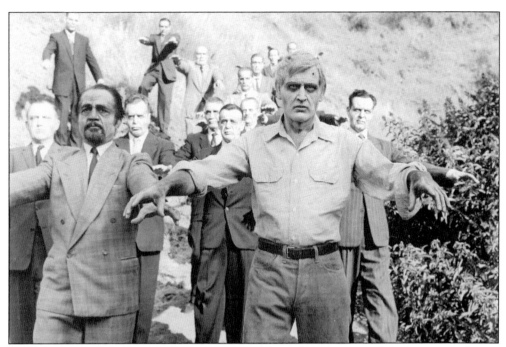

INVISIBLE INVADERS, 1959. As relentless as telemarketers, these reanimated dead pursue the living. Employing a plot that would be resurrected, zombie-like, again and again, in several low-budget horror films of the 1950s, the movie starred John Agar, Jean Byron, and John Carradine. In this scene, these "invisible invaders" (who look surprisingly visible here) trudge through Bronson Canyon.

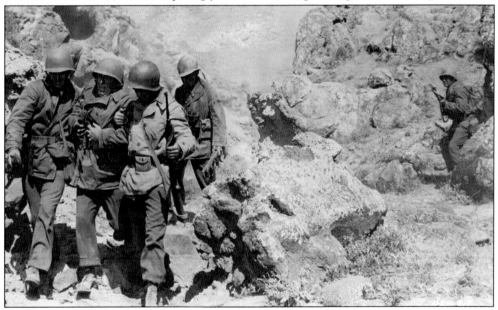

THE DEEP SIX, 1958. Soldiers climb through Bronson Canyon in this World War II drama that stars Alan Ladd as a reluctant warrior. Ross Bagdasarian, who has a small part in the film, was a prolific song composer. As David Seville, his novelty single *Witch Doctor* scored a number-one hit that same year. Bagdasarian was the cousin of dramatist William Saroyan and was later the creative force behind *Alvin and the Chipmunks.*

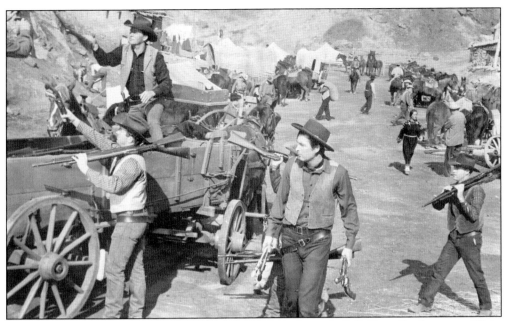

THE JAYHAWKERS!, 1959. Fess Parker (center) starred alongside Jeff Chandler (see page 93) in 1959's *The Jayhawkers!*, a film set during the turbulent pre–Civil War era in Kansas. Parker was between his two successful Disney television series—*Davy Crockett* and *Daniel Boone*—at the time he filmed this scene in Bronson Canyon. After his retirement from television, Parker became a successful vintner before passing away in 2010.

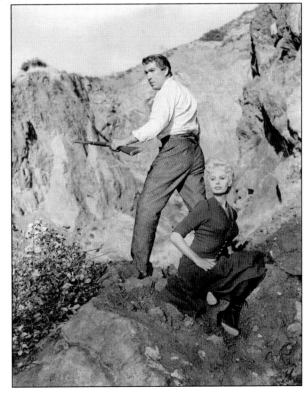

HELLER IN PINK TIGHTS, 1960. Anthony Quinn (left) and Sophia Loren appear in Bronson Canyon in this scene from *Heller in Pink Tights*. This Technicolor Western was based on a Louis L'Amour novel and was directed by George Cukor. Cukor worked briefly on two American classics in 1939—*Gone With the Wind* and *The Wizard of Oz*—before being replaced on both films by director Victor Fleming.

King of the Wild Stallions, 1959. Bronson Canyon is the castle for this king—a black stallion known as Lightning. In this scene, Bucky Morse, played by 13-year-old Jerry Hartleben, attempts to capture Lightning while his dog looks on. Edgar Buchanan had a costarring role in this film (as well as in *Ride the High Country* [below]). Buchanan was a dentist in Altadena, California, before going into acting.

Ride the High Country, 1962. Randolph Scott made his final screen appearance in this highly regarded Western, which costarred Joel McCrae, Mariette Hartley, Ron Starr, and Edgar Buchanan. This film, which solidified the reputation of director Sam Peckinpah, was mostly shot in the "high country" of the Sierra Nevada mountains. But in this scene, Hartley, Starr, McCrea, and Scott (from left to right) ride through Bronson Canyon.

THE GUN HAWK, **1963.** Talk about coming full circle! Rory Calhoun (right) and Rod Cameron ride through Bronson Caves during this scene from *The Gun Hawk*. This is one of the few times on film where both cave openings are shown, revealing that Bronson Caves is actually a tunnel. Calhoun was born Francis McCown and spent much of his youth in prison until being paroled just before turning 21. After leaving San Quentin, he drifted through a series of jobs before meeting Alan Ladd (see page 120) in 1943 while riding a horse in a Los Angeles park. Ladd introduced McCown to a Hollywood agent named Henry Wilson. Wilson gave McCown the name Rory Calhoun and steered his career with an iron grip. For the next half-century, Calhoun would appear in, produce, or write for several films and more than 1,000 episodes of television. And just where was Calhoun riding the horse the day he was discovered by Alan Ladd? That's right—Griffith Park.

SOLDIER IN THE RAIN, 1963. *Soldier in the Rain* stars Jackie Gleason, Steve McQueen, and Tuesday Weld. In this scene, McQueen cheers on runner Pfc. Jerry Meltzer, played by actor Tony Bill. In 1974, Bill would win the Oscar as producer of the Best Picture winner, *The Sting. Soldier in the Rain* had the unfortunate timing of being released the same week that JFK was assassinated and fared poorly at the box office.

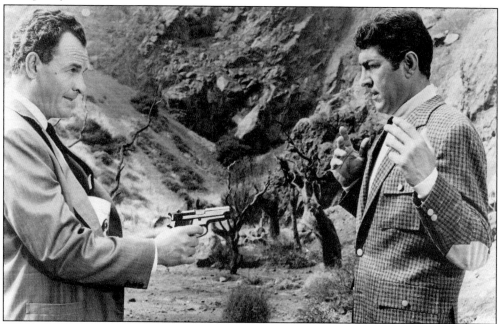

THE SILENCERS, 1966. "Girls, Gags, & Gadgets! The Best Spy Thriller of Nineteen Sexty-Sex!" So proclaimed the posters for *The Silencers*, the first in a series of four late-1960s, spy-movie spoofs. The films starred the womanizing photographer and spy Matt Helm, played by Dean Martin (right), seen here with actor James Gregory in Bronson Canyon. The films, which spoofed the *James Bond* series, later influenced the *Austin Powers* movies.

THE SPLIT, **1968.** Jim Brown (right) stars with Diahann Carroll in this scene shot at the Griffith Observatory. In the film, Brown and his gang pull off a heist at the Los Angeles Coliseum during a football game. The coliseum was a familiar venue for the former football great, who played there often as a member of the Cleveland Browns during his nine-season, Hall of Fame career.

CUTTER'S WAY, **1981.** In this scene from the thriller *Cutter's Way,* friends Alex Cutter and Richard Bone, played by John Heard (left) and Jeff Bridges, argue while watching a polo match at Griffith Park's Equestrian Center. The Equestrian Center is separate from the bulk of the park, cut off from its northern end by the Los Angeles River and the 134 Freeway.

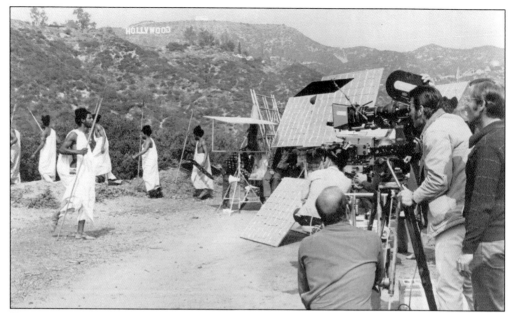

TRADER HORN, 1973. *Trader Horn* was a remake of a 1931 Academy Award–nominated adventure film that holds the distinction of being the first non-documentary to be shot on location in Africa. These two photographs show images from the 1973 version of the film, which was shot in Bronson Canyon. In the above photograph, director Reza Badiyi is seen pointing. The choice to use Bronson Canyon for the film's remake was a wise one. While filming the original movie in Africa, Edwina Booth, one of the film's stars, contracted malaria, which ended her career. She fared better than others on the set—one of the crew members was killed by a charging rhino, and another was eaten by a crocodile!

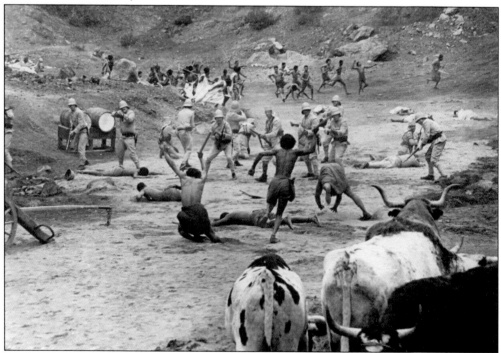

STAR TREK VI: THE UNDISCOVERED COUNTRY, 1991. *Star Trek* creator Gene Roddenberry died shortly before the premiere of this film, which was the last one to feature the entire original *Star Trek* cast. This photograph shows sets being created for the film near Lake Hollywood, a man-made reservoir just outside the park's southern boundary. The Hollywood Sign is visible off in the distance.

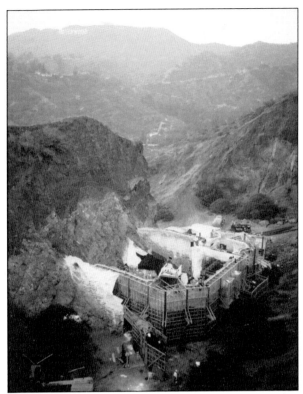

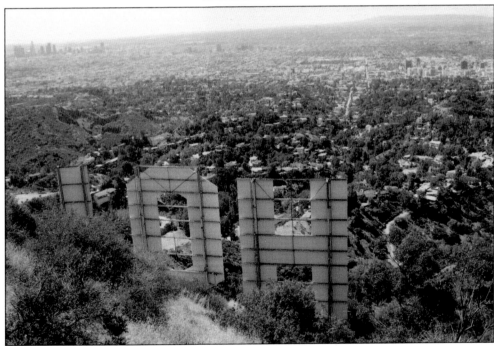

HOLLYWOOD SIGN, 2011. This view, looking down on the Hollywood Sign towards where *Star Trek VI* (above) was filmed in 1991, can only be seen in Griffith Park. The park is still the most popular place to film in Los Angeles County, boasting 341 days of production in 2010.

DISCOVER THOUSANDS OF LOCAL HISTORY BOOKS FEATURING MILLIONS OF VINTAGE IMAGES

Arcadia Publishing, the leading local history publisher in the United States, is committed to making history accessible and meaningful through publishing books that celebrate and preserve the heritage of America's people and places.

Find more books like this at
www.arcadiapublishing.com

Search for your hometown history, your old stomping grounds, and even your favorite sports team.